P.O. BOX 424 CINCINNATI, OHIO 45202
(513) 351-ARTS

THE BLACK BOOK:

The True Political Philosophy
of
Malcolm X
(El Hajj Malik El Shabazz)

Edited & Compiled by

Y. N. Kly

CLARITY PRESS

ISBN: 0-932863-03-5
LCCN: 86-072174

1st printing: 1986
2nd printing: 1987
3rd printing: 1988

Cataloguing in Publication Data:

Main entry under title:
 The Black book: the true political philosophy of Malcolm X (El Hajj Malik El Shabazz)

Bibliography: p.
ISBN 0-932863-03-5

1. X, Malcolm, 1925-1965. 2. Black Muslims-Biography. 3. Afro-Americans-Biography. 4. Black nationalism. 5. Islam and social problems. I. Kly, Yussuf Naim

BP223.Z8L5725 1986 973:0496 C86-090310-9

Printed in the U.S.

CLARITY PRESS

Suite 469, 3277 Roswell Rd. N.E.
Atlanta, GA. 30305, USA

and

P.O. Box 3144
Windsor, Ont. N8N 2M3
Canada

DEDICATION

This effort at presenting the true political philosophy of America's first muslim martyr, El Hajj Malik El Shabazz, is dedicated to the memory of the Christian mujahideen, Dr. Martin Luther King, Jr., and to America's most recent muslim martyrs, Dr. Ismail Laqi A. al Faruqi and his wife, Lamya, who died in Philadelphia on May 27th, 1986. Both were Arab Americans and crusaders for Islamic development in the U.S. under the direction of American muslims. All three, like Malcolm X, lived and died like muslim martyrs.

"We are living in an era of revolution, and the revolt of the American negro is part of the rebellion against the oppression and colonialism which has characterized this era...

"It is incorrect to classify the revolt of the Negro as simply a racial conflict of black against white, or as a purely American problem. Rather, we are today seeing a global rebellion of the oppressed against the oppressor, the exploited against the exploiter.

"The Negro revolution is not a racial revolt. We are interested in practicing brotherhood with anyone really interested in living according to it. But the white man (Anglo-American) has long preached an empty doctrine of brotherhood which means little more than a passive acceptance of his fate by the Negro...

"(The Western industrial nations have been) deliberately subjugating the negro for economic reasons. These international criminals raped the African continent to feed their factories, and are themselves responsible for the low s tandards of living prevalent throughout Africa."

Malcolm X Speaks, p. 233.

"Power in defence of freedom is greater than power in behalf of tyranny and oppression, because power, real power, comes from conviction, which produces action, uncompromising action. I t also produces insurrection against oppression. This is the only way you end oppression -- with power.

"Power never takes a back step -- only in the face of more power. Power doesn't back up in the face of a smile or in the face of a threat, or in the face of some kind of nonviolent loving action. It's not the nature of power (whether it be the traditional negro leadership or their Anglo-American sponsors) to back up in the face of anything but more power. And this is what the people have realized in Southeast Asia, in the Congo, in Cuba, in other parts of the world. Power recognizes only power, and all of them who realize this have made gains.

Malcolm X Speaks, p. 158.

APPRECIATION

We would like to thank all those individuals and former members and associates of the O.A.A.U. in New York's Harlem, in Montreal, Quebec, and in Chicago whose cooperation makes this book possible. We call special attention to the cooperation and assistance given to us by Albert Jabera, Dr. Charles Knox, Dr. Yvonne King, Qasem Mahmoud, Ibn Sharieff and Diana Collier.

This book seeks not to confuse our readers by presenting each tree in the forest through which Hajji Malik El Shabazz traveled and of which he spoke, but instead to present a clear picture of the forest -- the true political philosophy he was in the process of developing.

However, we sincerely submit that any contradictions or non-Islamic presentations in this work are due to our interpretation of Malcolm's philosophy and not necessarily to that philosophy itself and in no way should be construed to detract from the greatness of one whom many have come to consider a great Muslim martyr.

TABLE OF CONTENTS

PREFACE

THE METHODOLOGY

At the beginning of the spring of 1961, shortly after completing the B.A. in Political Science and International Relations from the University of Iowa, I began to attend various Islamic and community meetings and conferences in which I had the opportunity to attempt to understand the political nature of the philosophy that Malcolm X expounded. Between the years 1961 up to 1964, I, like thousands of other Americans, joined the fight against the apartheid system in the U.S. South which had forced many into the North or foreign exile. I posed a series of questions to Malcolm twice during private interviews, but most often in open meetings. Thus the responses which I received were not focused on me but rather were the message he wished to convey to everyone.

In the fall of 1964, my recording and study of Malcolm's responses and my understanding of their political meaning led me to enter the U.S. struggle by seeking and receiving the chairmanship of the Montreal International Branch of Malcolm X's organization, the O.A.A.U. (Organization of Afro-American Unity).

Recently in reviewing the 87 recorded questions that I had posed and Malcolm's responses to same, I realized that many of the questions posed were for the most part essentially the same question asked in different ways to secure a fuller understanding, and thus could be logically reduced to approximately twenty questions and responses. *The Black Book of Malcolm X* is no more than the faithful combining of the 87 questions and responses received, and an abstraction of the political philosophy from the responses given. For the purpose of clarification, all terminology used in this book, such as "people," "state," "nation," etc., conforms to its current meaning in international law, which may be obtained from an international law dictionary.

CRITERIA

In abstracting the political philosophy of El Hajj Malik El Shabazz, apart from our primary source (his recorded responses to questions posed between 1961-1964), we have evaluated the importance of

his responses and their political meaning through a study of the researches listed in the bibliography. That is, we looked at what he said to others, and what other scholars interpreted, to determine if there were any significant contradictions between our interpretation and that of other interpreters. We found no significant contradiction. In fact, most other writers did not attempt to abstract a political philosophy from his acts and statements. We also viewed Malcolm's concepts to see if they fell within the range of international law. This was important because if Malcolm was concerned with outlaw political ideas or philosophies, we would have felt obliged to present them as such. However, we found none of his responses to be unlawful or politically unique. Equally we wished to assure ourselves that Malcolm was not morally hypocritical in professing Islam at the same time as he professed a political philosophy contrary to it. After scrutinizing his responses in relation to the Quran, sunni and political philosophy of Islam, and securing the opinion of Muslim scholars in Ottawa, New York and Chicago, we found that Malcolm's political philosophy also met Islamic standards, and Malcolm's actions and words indicated that he was Muslim. This means that when evaluating a statement by Hajji Malik El Shabazz or searching for its meaning, we do not ask which traditional negro leadership orientation it follows in order to secure its significance and meaning, but instead we give Malcolm the full measure of his humanity by searching for its meaning in international law and his personal beliefs in the Islamic religion. In this way, we view Malcolm as he viewed himself, fathered by Islam from the wound of the culture that grew out of African enslavement in the U.S., the child of his day, the African-American, the American Muslim.

HAJJI MALIK EL SHABAZZ
The American, The Afro-American, The Muslim

It is ironic that when most Americans think of Malcolm X, they think of him as un-American or anti-American. However, this is no doubt due to confusion between his being against certain government policies, as opposed to being anti-American. When we look unemotionally at the political philosophy of Malcolm X, there can be little doubt that Malcolm's values represented a far greater integration into the American majority value system than, say, the political

philosophy of the honorable Dr. Martin Luther King, Jr. While King's absolute belief in non-self-defense or nonresistance against violent aggression reflected strong Hindu or Buddhist orientation, Malcolm's philosophy was really about the same as any majority American would hold, given similar circumstances and grievances. In short, Malcolm's values were no less American than were the values leading to the revolutionary wars of 1776 and 1812, the Civil War, and those leading to the First and Second World Wars.

Hajji Malik El Shabazz was only considered un-American or anti-American because he was opposed to the philosophy of "white superiority" and to the necessity of black Americans to permit and submit to "white privileges."

It is a paradox in the U.S. system that once a black strives towards the societal goal of assimilation of majority values, this must automatically mean opposition to the majority's privileged position, and thus his castigation as being un-American or anti-American. In evaluating the philosophy of Hajji Malik El Shabazz, we find that he, like most Americans, feels that one should be willing to fight and die if necessary to obtain equality and freedom. And while we concede the wisdom of his call for self-determination for the national minority, we feel that such a policy at present is only feasible or desirable within the context of maintaining national unity and national security (along the models presently in operation in Switzerland, the interdependent republics of the U.S.S.R., the equal representation model of the minorities in Yugoslavia or the proportional representation model of those in Belgium and Canada.) However, each equal status model evolved through the unique historical development of the country in which it is found, and each differs accordingly. Thus, while the model developing in the U.S. may borrow principles from many of the other successful models, it will be uniquely American and evolved only out of the successful communications and negotiations between the parties in conflict.

We do not concede to Malcolm's -- and many black nationalists' and leftists' -- orientation that self-determination for Afro-Americans must result from or lead to the decline of the U.S. as a world power. Rather, we believe that recent history indicates that the U.S.' decline as the major world power is well underway, although the U.S. continues its oppression of Afro-Americans. However, we agree that

while the U.S. ruling elites maintain oppression of Afro-Americans, it is equally true that the U.S. is also Afro-Americans' home, and perhaps brightest hope. Thus the question should never be: how to destroy America, but instead, how to make one's home non-oppressive. Therefore, we believe that self-determination for the Afro-American may lead to the rebirth of America or the birth of the true American ideals. This would be true because of the following reasons:

1. It would provide the U.S. with the circumstances and paraphernalia necessary to compete successfully with the U.S.S.R. for the sincere allegiance of most of the world's people, particularly in the Third World, but also in Europe (where the U.S. model is presently in decline).

2. It would to a significant degree help the U.S. overcome its social and educational problems. When a nation is forced to attempt to ignore history and current reality in order to maintain the oppression of a people, it sets in motion a diseducational movement whose techniques and principles cannot be limited to areas necessary to maintain the oppression, but rather spreads to all areas of education and social thought, leading to grave social disarticulation and silliness.

3. Perhaps most importantly, self-determination for the Afro-American would mean a great leap in American productivity. It would mean releasing a group of more than 30 million people out of the harness of Anglo-Saxonization and the straight-jacket of assimilation, and placing them in a political framework which would permit them to develop themselves and their culture, etc. -- which means the expansion of American institutions, industry, identity, perception, output, etc..

Often Malcolm's enemies call attention to some of his earlier statements to imply that he was racist, but these earlier statements should be properly analyzed within the context of the situation wherein Anglo-Americans have led all Afro-Americans to believe that they represent the white people, that is, that all peoples who happened to be "white" were, like Anglo-Americans, responsible for the oppression of "non-white" and particularly black Americans, and shared the

same cultural, socio-political and economic biases. It is clear that Malcolm was never racist; he only hated the cruel and oppressive domination imposed on Afro-Americans by Anglo-Americans (whites). Indeed, this approach to understanding Malcolm is verified by the fact that when he returned from Mecca where he met non-Anglo-American and non-racist "whites", he immediately realized that the American culture and racist ideology does not, by any stretch of the imagination, represent white people: the vast majority of people who happen to be white, like the vast majority of people who happen to be black, have nothing against the Afro-American, and often see the American culture, as Malcolm did, as being corrupt, materialistic, degenerate and racist.

Thus when Malcolm realized that he had inadvertently been led into error by Anglo-American racist disinformation, he realised, being internationally orientated, that he must immediately correct his world perspective. Therefore, in this book we found no need to discuss the political philosophy of Hajji Malik El Shabazz in terms of the black/white issue inspired as an issue chiefly by Anglo-American imperialism and domestic racist disinformation. His political ideas instead are handled as universal concepts learned through the Afro-American experience for the benefit of mankind.

4. As B.F. Skinner so aptly implied in *Beyond Freedom and Dignity*, the safeguarding of human dignity and freedom for all Americans depends on the slave being conscious of his misery. The real threat to human dignity and freedom is not the slave revolt, but that system of slavery or oppression so well designed that it does not breed revolt. The happy slave or the satisfied oppressed people is a blasphemy against the freedom and dignity of all people, and particularly against the equality of the group to which he belongs. Again, Dr. Skinner rightly calls our attention to the futility, even on the individual level, of seeking equality by accepting oppression. "Any evidence that a person's behavior may be attributed to external circumstances seems to threaten his dignity or worth. No matter what achievements an individual accomplishes,

we are not inclined to give a person credit for achievements which are in fact due to forces over which he has no control."

Jean Jacques Rousseau, in his celebrated work, *Emile*, caught the essence of what occurs when humans are successfully subjugated: "Let him believe that he is always in control, though it is always you who really controls. There is no subjugation so perfect as that which keeps the appearance of freedom, for in that way one captures volition (the will) itself..."

Self-determination for Afro-Americans at the present stage of development would probably mean nothing more than:

1. The official recognition of the Afro-American as a distinct national minority which elects Afro-American leaders by direct vote.

2. Politically encouraging one or more states to come under the socio-political control of an Afro-American majority.

The state apparatus presently in place would provide for sufficient politico-socio-financial autonomy.

Above, we have expressed our chief agreements and differences with what we analyzed to be the political philosophy of Malcolm X. We felt that this was appropriate since in the remainder of this text we have limited ourselves strictly to the presentation of the political philosophy of Malcolm X.

This is the first attempt to formulate the essence of Malcolm's final ideas from questions posed to him and from his instructions to the only organization he established before his death, the O.A.A.U. Since his ideas were formulated during the process of his attempt to liberate the black minority in the U.S., we feel that in the spirit of this effort it is appropriate to call this first attempt: **The Black Book.**

Y. N. Kly
Former Chairman
Canadian Branch of the
Organization of Afro-
American Unity (O.A.A.U.)

INTRODUCTION

Struggle and Martyrdom in Islam

Although the subject of struggle and martyrdom in Islam is much too vast and complex to be covered in this brief introduction, we feel it is helpful to attempt to present a generalized notion of the subject, in order to better understand the orientation and ideas of the first American muslim martyr, El Hajj Malik El Shabazz (Malcolm X) concerning revolution and national liberation.

In the Quran, there are provisions for the guidance of the many forms of political organization (including liberation movements) in times of peace, struggle and neutrality. This guidance forms the basis of what we may see as the similarity between the Islamic and international law view of struggle. Contrary to the two main premises frequently held with regard to struggle in Islam, one particularly by western world scholars, which regards all wars in Islam as *offensive*: the other held by many Muslim writers that Islamic struggles have always been *defensive*, the validity of struggle in Islam is based on neither premise. Both these orientations are based on wrong presumptions. The very consideration of offence and defence as the prime value criteria for struggle has doubtful legal and moral foundation in Islam. Struggle is always in the "way of God" and therefore it is conducted in accordance with God's Commandments. Thus it is the Quranic injunction that makes struggle valid; in this way, whether to struggle or not is a legal as well as a political question. For example, when a group is oppressed, struggle in Islam is *imperative*; it may be non-violent or armed struggle. However it is always under defined conditions that the waging of a struggle becomes valid or obligatory. The questions of offence or defence are only elements of the criteria. The whole moral force underlying struggle (*Jihad*), obedience to God's injunctions and God's rewards, would vanish if priority were given only to self-defence, although self-defence is often mentioned as one of the many conditions under which struggle is made obligatory on the community (*ummat*). Thus, to examine the Islamic position on struggle, one need only to determine the conditions or limits prescribed by God under which struggle is divinely enjoined or is justified.

> Fighting is enjoined on you, and it is an object of dislike
> to you; and it may be that you dislike a thing while it is
> good for you, and it may be that you love a thing,
> while it is bad for you, and God knows, while you do
> not know.[1]

Struggle is not to be avoided for fear of death, because:

> wherever you are, death will overtake you.[2]

THE PURPOSE OF THE STRUGGLE (JIHAD)

*The purpose of struggle in all its forms is to render a real
service to humanity;* the latter is often not possible without the former.
The Quran defined the goal of the believers thus:

> you are the best community raised up for (the benefit
> of) men: you enjoin what is right and forbid what is
> wrong and believe in God.[3]

It is therefore evidence that the believers were created for the
benefit of and service to humanity as they enjoin the right, which is the
highest ideal. *Struggle (jihad) is often the means by which this highest
ideal can be realized.* The believer is required to acquire power to
enjoin right and forbid wrong so as to further the cause of human
welfare. Thus it is the duty of those who struggle or come to power
after struggle to keep up prayer, pay Zakat and "enjoin good and
forbid wrong."

> And among you there should be a party who invite to
> good and enjoin what is right and forbid the wrong,
> and these it is that shall be successful.[4]

The Prophet said:

> It is incumbent on you that you seize the hand of the
> evil doer and turn it towards the good.[5]

However, struggle is not obligatory on the incapable.

> There is no harm (if) the blind... the lame... the sick...
> (etc.) do not go forth for armed struggle.[6]

Sons require the permission of the parents to join the armed struggle,
and married women should seek permission of their husbands to
participate.

Second to faith is struggle. Of all actions, struggle is the noblest, and all the sins, excepting debt, will be pardoned by God of the person who dies in the way of God with patience and sincere intention. So much so that one who earnestly prays for martyrdom (*Shahadat*) and yet dies a natural death will receive the rank of martyr (*Shahid*). Intention and action are the two ingredients to struggle. Eternal good, therefore, consists in one's commitment to all forms of just struggle, fasting, prayer and spending to support it. *Likewise good also consists in helping the persons (Mujahids) who are engaged in a just struggle by offering services to them.*

> When some (in an oppressed community) fight and others abstain, the latter are forgiven, but when all abstain, then all are sinners.[7]

Struggle is enjoined on the whole community; it is a collective undertaking and not an individual one.

The significance of *Jihad* may be determined from a saying of the Prophet Muhammed (Peace Be Upon Him) that:

> *no person who dies wishes to return to this world, but the martyr (Shahid) who wishes to return to this world so that he may again be a martyr.*[8]

THE MORAL SIGNIFICANCE OF THE JUST STRUGGLE

Jihad is a fight in the "way of God." The Prophet said:

> A section of my community will continue fighting for the Truth. (*Haq*) And God is the Protector of one who steps forward to wage struggle in the way of God.[9]

> So one who died and never engaged in struggle nor intended to fight dies like a *Munafiq*.[10]

> *Those who avoid struggle at all costs and those who struggle or are willing to struggle cannot be equal in status.*[11]

The Quranic injunction - "spend in the way of God and do not throw your lives in waste (*halakat*)"[12] -- implies that one should be willing to struggle and not be engrossed in materialistic considerations in preference to a necessary struggle. However, to enter struggle

with impure intent is not encouraged. One who is willing to wage struggle for the sake of money is like a laborer working for money.

> The best among you are those who fight in the way of God with their riches and their lives.[13]

The struggle should be without any selfish motives or objectives.

> Some fight for their name, others for wealth, others for their superiority, but he alone fights in God's way who fights so that the name of God be glorified.[14]

THE MUJAHID

Mujahids have been defined by Abu Da'ud as "people of God and ordered" to "ride forth."[15] *Mujahid* will have the garden as reward. All sins of the Mujahid will be effaced except debt.

However, the Mujahid, like other believers, is not exempted from his duties and obligations. The Quran enjoins all believers to:

> attend constantly to prayer... and stand up truly obedient to God.[16]

In case of fear and danger from the side of the enemy, the Mujahid is excused for shortening his religious duties exclusively in accordance with the following Quranic injunctions.

> But if you are in danger, then (say prayers) on foot or on horse back, and when you are secure, then remember God as God has taught you what you did not know.[17]

> And when you journey in the earth, there is no blame on you if you shorten the prayer, if you fear that those who disbelieve will molest you; surely, the unbelievers are your open enemies.[18]

Here the Quran permits and even advises persons engaged in a just struggle to take the necessary evasive action required to prevent their unnecessary persecution.

The Quran also gives instruction on how a community in struggle should look upon each other.

> The believers are but brethren, therefore make peace between breathren and be careful of (your duty to) God that mercy may be had on you.[19]

> Surely, God loves those who fight in God's way in ranks as if they were a firm and compact wall.[20]

> And if two parties of the believers quarrel, make peace between them but if one of them acts wrongfully toward the other, fight that which acts wrongfully until it returns to the right path; then if it returns, make peace between them with justice and act equitably, surely God loves those who act equitably.[21]

Islam further teaches that one should not seek to fight, but should do so only when it is valid and necessary.

> Do not wish to meet the enemy in battle but when you meet them be patient.[22]

Unlike the amoral statement of Mao Tse-Tung that "power comes out of the barrel of a gun," the Prophet, also realizing the necessity to struggle and the usefulness of power for the interest of maintaining righteousness in the world, states:

> Paradise is under the shadow of swords.[23]

Thus, there should be no hesitation or excuse in waging a just liberation struggle.

> O you who believe! what (excuse) have you that when it is said to you, Go forth in God's way, you should incline heavily to earth; are you content with the world's life instead of the hereafter? But the provision of this world's life compared with the hereafter is but little.[24]

> They only ask leave (from fighting) who do not believe in God and the latter day and their hearts are in doubt.[25]

It is also a fault for the rich to ask the poor to fight for them, but Islam emphasizes that the true the Mujahids will always be rewarded.

> Surely, God had bought from the believers their lives and their riches in order that they shall have the garden; they fight in God's way, so they slay and are slain... rejoice therefore in the pledge which you have made; and this is the mighty achievement.[26]

THE BLACK BOOK:

"Whenever circumstances demand, be ready"[27] is the order of the Prophet.

> And prepare against (the wrongdoers) what force you can... to frighten thereby... your enemy and others beside them... and whatever thing you will spend (in the way of just struggle), it will be paid back to you fully and you shall not be wronged.[28]

THE RIGHT TO LEAVE AREAS OF OPPRESSION OR WRONG DOING

Sometimes believers living under conditions of oppression in the territory held by the enemy were required to migrate. This is the way for those who could manage to flee, or for those for whom migration was a practical solution to their oppression.

> Surely (as for) those whom the angels cause to die, while they are unjust to their souls, they shall say; in what state were you? they shall say; we were weak in the land. They shall say; was not God's land spacious so that you should have migrated therein.[29]

> He it is who made this earth subservient to you, therefore, go about in the spacious side thereof.[30]

> Except the weak from among the men and the women and the children who have not in their power the means nor can they find a way (to escape).[31]

God will pardon them and God is forgiving.[32]

> And whoever flees in (the way of the just struggle), he will find in the earth many a place of refuge and abundant resources; and whoever goes forth from his house fleeing to God and his Apostle and then death overtakes him, his reward is indeed with God and God is forgiving, merciful.[33]

> And (as for) those who believed and fled and struggled hard in (a just struggle) and those who gave shelter and helped, these are the believers truly: they shall have forgiveness and honorable provision.[34]

And (as for) the foremost, the first of the *Muhajir* and
the helpers (*Ansar*) and those who followed them in
goodness, God is well-pleased with them and they
are well-pleased with God.[35]

The Prophet permitted migration from the land of the enemy.
But (Hijrat) does not only mean leaving one's country, but also includes
abstaining from sins or from things forbidden by God.

THE IMPORTANCE OF LIFE

Although struggle and war is accepted in Islam as an unfortunate
necessity, an equally important principle of Islam is that life is to be
respected and the right to life is to be accorded to all beings.
Struggle is enjoined on the believers against mischief.

Whoever slays a soul, unless it be for manslaughter or
for mischief in the land, it is as though he slew all
mankind, and whoever keeps it alive it is as though he
kept alive all mankind.[36]

Understanding the importance of human life in Islam, it follows that
Islam is as much against unjust struggle or revolt as it is for a just struggle.
"The way of God is also against those who oppress men as well as
those who seed revolt in the earth (unjustly); these shall have a painful
chastisement"[37] because life cannot be taken away except in the
requirement of truth or a just struggle. That which would prescribe truth
consists in the conditions under which struggle can be waged.

The first condition is that the slaying of a soul is permitted in the
case of manslaughter, as a due process of truth.

The second condition is that *Jihad* can be waged for the
suppression of mischief or oppression. Oppression of men is the form
of mischief that is regarded as a greater offense than murder.

And God does not love the oppressor or mischief
makers.[38]

Both individual as well as organized mischief, or oppression, is
condemned in Islam, because to allow mischief and oppression
permits the creation of conditions wherein there can be no just basis
for law or order in the world. Justice and equity are seen as the
fundamental requirement of law and order.

DUTY TO HELP THE POOR AND OPPRESSED

It is the duty of all believers to help the poor and oppressed.

> And what reason have you that you should not fight in the way of God and for the weak among the men and the women and the children (of) those who say: Our Lord! cause us to go forth from the town, (whose people are oppressors) and give us from You a guardian and give us from You a helper.[39]

Thus those who fight to suppress cruelty or oppression fight in the way of Islam.

The Quran teaches the believers to be tolerant of all conditions except when an attempt is made by their adversaries to annihilate their religion or to deprive a community of their liberty and rights. Under such circumstances, the believer is duty bound to inflict such punishment on would-be oppressors as may set them right.

> Sanction is given unto those who fight because they have been wronged... surely God will help him, who helps God's cause.[40]

> And fight in the way of God with those who fight with you and do not exceed the limits.[41]

> And kill them wherever you find them, and drive them out from whence they drove you out.[42]

> Permission is given to those, upon whom war is made, (to keep them oppressed)... and those who have been expelled from their homes without a just cause.[43]

Thus the Quran upholds its own distinct universal ethical ideal, that of enjoining good and forbidding wrong wherever. A clear distinction is made between right and wrong or virtue and evil. Believers are called upon to uphold the right and suppress the wrong. This principle also applies to matters of struggle. For the honor of the community, it is essential to free other communities from the slavery of enemies of truth: there can be no excuse of weakness or otherwise; the alternative is to assist them in migration from the land of oppression and tyranny.

It follows that just struggle can be waged in sympathy with other brethren in faith. The believers are commanded to fight in the way of God to support the weak and those who seek help in the name of faith.

> And what reason have you that you should not fight in the way of God and for the weak among men, women and children.[44]

> And if they seek aid from you in the matter of faith, aid is incumbent on you except against a people with whom you have a treaty.[45]

However fighting is enjoined on those who break their treaty.

> And if they break their oaths after their agreement and (openly) revile your belief, then fight the leaders of unbelief.[46]

> What will you not fight a people who broke their oaths... and they attacked you first; do you fear them.[47]

THE STRUGGLE AND REWARD

> And we desired to bestow a favor upon those who were deemed weak in the land and to make them the leaders and to make them the heirs.[48]

> And (as for) those who strived hard for Us, We will most certainly guide them in Our way.[49]

> O you who believe! If you help (the cause of) God, God will help you and make firm your feet.[50]

> God is his protector who wages a struggle in God's way.[51]

> Therefore let those fight in the way of God who sell this world's life for the hereafter: *and whoever fights in the way of God will be victorious.* We shall grant him a mighty reward.[52]

The just struggle has it own reward.

> *And (as for) those who are slain in the way of God,*
> *God will by no means allow their deeds to perish.*[53]

For those who die in the way of God, there is Divine mercy.

> *And if you are slain in the way of God, or you die,*
> *certainly forgiveness from God and mercy are better*
> *than what they amass.*[54]

And if you indeed die or you are slain, certain to God shall you be gathered.[55]

The highest reward is that the martyrs (souls and deeds) are not supposed to die, but will always live.

> And reckon not those who are killed in God's way as
> dead; nay, they are alive (and) are provided
> sustenance from their Lord.[56]

ADVANTAGES ACQUIRED IN STRUGGLE

Those of the people who struggle and do not take earned advantage are higher in God's estimation than others.

> One who fights and earns spoils is less creditable than
> the one who fights and does not earn spoils.[57]

Islam does not permit stealing the goods of others. The Quran orders the distribution of things acquired in the following manner:

> And know that whatever thing you acquire in war, a
> fifth of it is for God and for the (leader) and for the
> near of kin and the orphans and the needy and the
> wayfarer.[58]

Accordingly the remaining four fifths is to be distributed among those who struggle.[59] Sale of things acquired before their distribution in the above manner is forbidden.[60]

CAPTIVES OR PRISONERS

The first principle is that captives can only be taken in a successful Jihad. The Quran bears testimony to this principle in the following words:

> It is not fit for the Prophet that he should take captives
> unless he has fought and triumphed in the land.[61]

Therefore the Prophet is commanded:

> If they come to you as captives, you should ransom them.[62]

Thus, the second principle is to free or ransom the captives or prisoners.

The third principle is that captives are not to be killed or harmed. They are also to be given asylum, if requested.

> And if any one of (them) seek protection from you, grant them protection.[63]

The fourth principle is that the captives are to be properly fed:

> And they (the righteous) give food out of love for God, to the poor and the orphan and the captive.[64]

The fifth principle is mentioned in the *Ahadith* that:

> Captives are not to be (forced) to accept Islam (or any other ideology).[65]

PEACE AND VICTORY

When the Prophet sent anyone on any mission, he asked him to convey good news, not create bitterness, make matters smooth and not create impediments.

> God does not forbid you to respect those who do not (oppress you or) make war against you on account of (your) religion, and have not driven you from your homes, so show them kindness and deal with them justly; surely God loves the doers of justice.[66]

Here the Quran encourages the seeking of peace with justice, and it tells us that *if we are willing to continue fighting, then the peace will be one that will bring victory for the just cause.* This means that in struggle, peace and justice should be pursued simultaneously and only when the enemy is willing to negotiate a just solution, can peace be accepted. In Islam, struggle is never fought to inflict injustice on the enemy even if he loses, but instead to have both the military victor and vanquished accept a just and equitable solution.

> And be not weak so as to cry for peace and you will
> have the upper hand and God is with you, and God
> will not bring your deeds to naught.[67]

> And if they incline to peace (with justice), then incline
> to it and trust in God.[68]

Even when the enemy offers peace by way of deceit, the believers
should not reject this offer without investigating whether it could bring
about a just and equitable solution to armed conflict.

> And if they intend to deceive you, then surely God is
> sufficient for you.[69]

> O you who believe! when you struggle in God's
> way, make investigation and do not say to any one
> who offers you peace: you are not a believer.[70]

Islam also points out that it is not wrong, if the enemy is too
powerful, to move from armed struggle to non-violent resistance and
perhaps at a more opportune moment return to armed struggle.

> And there is no blame on you, if (when) you are
> depressed by material circumstances or sick, that
> you lay down your arms and take your precautions.[71]

RESPECT FOR AGREEMENTS

Islam places great importance on the necessity for agreements
to be upheld. It even provides the leader of a just struggle with a
method to encourage upholding of agreements when it suggests that
if individuals make an agreement on behalf of the oppressor
community (like the Anglo-American's treaty with the native
Americans) and they do not uphold the agreement they made, and if
this leads to armed struggle, the oppressed or believer should
attempt to single out and make an example of the individual or
individuals who made the agreement on the part of the oppressor
community instead of striking back blindly and unjustly, in order to
discourage others. This is extremely important when we remember
the key role played by those who actually make the treaty in
maintaining the terms of the treaty and when we consider the
importance of upholding agreements to the success of negotiations
to end conflicts involving many lives.

Those with whom you make an agreement, then they break their agreement every time and they do not guard (against punishment), therefore, if you overtake them in fighting, then scatter them by making an example of them to those who are in the rear, that they might be mindful.[72]

And if you fear treachery on the part of the people (but do not know for sure) then go back to them on terms of equity; surely God does not love the treacherous.[73]

Aid is not incumbent against those with whom there is a treaty.

And if they (fellow brethren in the faith or people whom you should assist) seek aid from you in the matter of religion, aid is incumbent on you except against a people between whom and you there is a treaty.[74]

Agreements are made on the basis of Islamic law and should be kept.

So long as they are true to you, be true to them.[75]

It also is emphasized in the codified and written traditions of Islam (Hadith) that contracts, promises and agreements should be fulfilled.[76]

CONCLUSION

Struggle and martyrdom in Islam is a very complex subject that could well cover several volumes of research over a lifetime. However, from the brief highlights in this article, we can clearly see that like all areas of community life, struggle is harmonized with all other areas and with Islamic law. Thus martyrdom such as that of El Hajj Malik El Shabazz results truly from acts intended to uphold the highest ideals of mankind.

FOOTNOTES

[1] Al-Quran, 2:216.
[2] Ibid, 4:78.
[3] Ibid, 3:110.

[4] Ibid, 3:104.
[5] Muslim, Intikhab-i-Hadith--Mawlana Muhammad Ja'far Shah, p. 392.
[6] Al-Quran, 48:17.
[7] Nisal, vol. 11, p. 7.
[8] Muslim, vol. v, p. 2013.
[9] Abu Da'ud, p. 591.
[10] Ibid, 598.
[11] Ibid, 599.
[12] Ibid, 601.
[13] Ibid, 605. Nisal, vol. 11, p. 10.
[14] Nisal, vol. 11, p. 19.
[15] Abu Da'ud, p. 615.
[16] Al-Quran, 2:238.
[17] Ibid, 4:103.
[18] Ibid, 4:101.
[19] Ibid, 49:10.
[20] Ibid, 61:4.
[21] Ibid, 49:9.
[22] Muslim, vol. v, p. 1841.
[23] Ibid, p. 1841. Bukhari, vol. 11, p. 70.
[24] Al-Quran, 9:38.
[25] Ibid, 9:45.
[26] Ibid, 9:111.
[27] Bukhari, p. 352.
[28] Al-Quran, 8:60.
[29] Ibid, 4:97.
[30] Ibid, 4:100.
[31] Ibid, 4:98.
[32] Ibid, 4:99.
[33] Ibid, 4:100.
[34] Ibid, 8:74.
[35] Ibid, 9:17.
[36] Ibid, 5:35.
[37] Ibid, 42:42.
[38] Ibid, 5:67.
[39] Ibid, 4:75.
[40] Ibid, 22:39.
[41] Ibid, 2:190.
[42] Ibid, 2:191.

43Ibid, 22:39-40.
44Ibid, 4:75.
45Ibid, 8:72.
46Ibid, 9:12.
47Ibid, 9:13.
48Ibid, 28:5.
49Ibid, 29:69.
50Ibid, 47:7.
51Muslim, vol. v., p. 2011.
52Al-Quran, 4:74.
53Ibid, 47:4.
54Ibid, 3:157.
55Ibid, 3:158.
56Ibid, 3:169.
57Muslim, vol. v., p. 2032.
58Al-Quran, 8:41
59Muslim, vol. v, p. 1857.
60Tirmidhi, vol. I, p. 297.
61Al-Quran, 8:67.
62Ibid, 2:85. Tirmidhi, vol. I, p. 278. Abu Da'ud, pp. 654 -55. Bukhari, vol. II.
63Al-Quran, 8:72.
64Ibid, 76:8.
65Abu Da'ud, p. 653.
66Al-Quran, 60:8.
67Ibid, 47:35
68Ibid, 8:61.
69Ibid, 8:62.
70Ibid, 4:94.
71Ibid, 4:102.
72Ibid, 8:56-57.
73Ibid, 8:58.
74Ibid, 8:72.
75Ibid, 9:7.
76Intikhab-i-Hadith--Mawlana Muhammad Ja'far Shah pp. 291-292.

THE BLACK BOOK:

The True Political Philosophy
of
Malcolm X

FOREWORD

Over the past decade since the untimely death of El Hajj Malik El Shabazz, better known as Malcolm X (may God rest his soul), there have been many attempts by negro traditionalist and socialist writers as well as special interest groups to give political interpretation to the philosophy or message of Malcolm X. Unfortunately, and for various different reasons, these attempts have fallen far short of presenting an integrated political picture of Malcolm the man or Hajji the political leader. Negro traditionalist writers having almost no contact with the Islamic philosophy and civilization by which Malcolm was inspired and self-educated, generally make the mistake of concentrating their understanding short of an Islamic input, and thus negating the importance of Malcolm's Islamic develpment. After all, it is the period after his contact with universal Islam that distinguished the philosophy of Hajji Malik El Shabazz from that of traditionalist negro leaders.

On the other hand, socialist scholars rightly realize that after his break with The Honorable Elijah Muhammad, Malcolm developed a distinct political philosophy of national liberation, but they confuse his development of a distinctly political philosophy with having dropped Islam as a guiding orientation, and thus in interpreting him they tend to ignore too much the Islamic as well as pre-Islamic background and depth of his thinking. This results in a confused understanding of his view of *national liberation and revolution and a tendency to interpret his concept of national liberation as interchangeable at all points with his concept of revolution.*

Special interest groups, such as organizations that sincerely attempt to follow his philosophy, have allowed the program of their organizations as well as the limitations imposed on its operations to control too greatly their conceptualization of Malcolm's philosophy (a little bit like putting the wagon in front of the horse, with the horse

obliged to go wherever the wagon is obliged to turn.) Thus, touching parts of an elephant, they describe the part that they touch accurately, but do not conceptualize or perceive the whole. Most writers up to this point have been satisfied with looking at various statements by Malcolm without analyzing and putting these statements together to relate their political import. It is uniquely the political import of Malcolm's views that we are concerned with in this book.

Thus, we hope to bring into existence a book which reflects the political wisdom and experience of the black (Americans of African descent) throughout their now 300 years of stay in the U.S.. Some of that wisdom and understanding, as comprehended and articulated by Hajji Malik El Shabazz, should be of use to all peoples fighting domestic oppression, and to those who seek answers to the questions of peace, happiness and progress, and future solution to the American dilemma.

HAJJI MALIK EL SHABAZZ
BIOGRAPHICAL STATEMENT

Hajji Malik El Shabazz was born, like most Afro-Americans, with a Christian first name, "Malcolm", given to him by his parents, and a last name, "Little", originally belonging to some Anglo-American who in the past had enslaved one of his ancestors and ignored his real family name (to be forever lost). In this way, "Malcolm Little" was born in Omaha on May 19, 1925, the fourth of eight children of the Rev. Earl Little, a Baptist preacher from the same state of Georgia as Malcolm's first teacher, The Honorable Elijah Muhammad. His mother, Louise, was from the West Indies. Hajji Malik El Shabazz was taxed with the same experiences as most Afro-American families of his economic status, and like most Afro-Americans of his economic status and situation, he participated in the same various questionable economic, moral and psychological activities for survival.

Unlike most Afro-Americans, Hajji Malik El Shabazz refused to accept his oppressed condition and the condition of his people as a *fait accompli*. Unlike most Afro-Americans, Hajji Malik El Shabazz accepted the teaching of The Honorable Elijah Muhammad while in prison for burglary (1951-52) at the age of about 22 years; refused to continue to bear and progenerate the name of the Anglo-American

THE BLACK BOOK:

who had enslaved his ancestors, took "X" as a last name to signify this refusal and the acceptance of the Islamic religion; and became a Minister for the Nation of Islam under the direction of The Honorable Elijah Muhammad.

Shortly afterwards, under the guidance of Dr. Mahmoud Youssef Shawarbi, Imam of the New York Islamic Center, Hajji Malik El Shabazz accepted Sunni Islam as his personal faith, made the hajj to Mecca, and traveled to Africa wherein he became engaged with the following three major concerns that occupied the remainder of his attention until his untimely death in the Audubon Ballroom that winter Sunday of 1965:

1) The introduction of the Islamic civilization into America

2) The introduction of the Afro-American question to the United Nations

3) The organization of an authentic internationally-recognized Afro-American national liberation movement

4) The replacement of the irresponsible traditional negro leadership, for without this no meaningful changes or new conceptualizations could reach the masses

YESTERDAY -- TODAY -- AND TOMORROW?

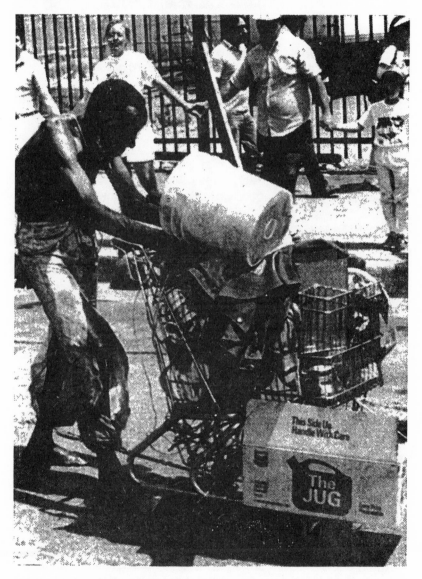

Street person Willie McGee passes Hands Across America participants in Los Angeles

THE BLACK BOOK:

THE UNIVERSAL LINKAGE
OF THE AFRO-AMERICAN PROBLEM

(NOTE:
*PROBLEM: The essential problem involved and summarized
from several questions which Malcolm X was actually asked*

*RESPONSE: The actual answer Malcolm X gave, combined
with an analysis and logical extension and elucidation of the
answer Malcolm gave.)*

PROBLEM: Should the problem of the black minority in the U.S. be
limited to solutions suggested in the U.S. historical development, such
as assimilation and the equality of all individuals before the law?

RESPONSE: No! The problem of the black minority in the U.S. is only
unique to U.S. circumstances to the extent that it resulted from the
transportation of enslaved Africans to the U.S., and that up to the time
of Malcolm X, all solutions were sought within the context of the U.S.
institutions and experience. However, Malcolm thought of the black
minority in the U.S. as a national minority or people (not a state) under
the domination and oppression of the generally white *Anglo-
Americanized* majority in the U.S.. Thus the problem of the black
minority in the U.S. should be formulated in such a manner as to
coincide with the universal problem of oppressed peoples or
minorities or nations without states in multi-national states such as the
U.S., etc..

Just as the ideals of the nation-state dominated the views of
scholars of international relations during the 19th century, the problems
of national ethnic minorities (nations without states) will remain an
important focus of attention and catalyst of international crisis and
tensions for the remainder of this century and the next because,
regardless of its original direction, the awakening of national
consciousness in 19th century Europe was subsumed in the creation of
an international system composed overwhelmingly, not of nation
states, but of multi-national states. The fact that since 1945 there has
existed a similar development of national consciousness in all parts of
the world, even within multi-national states, suggests that the search for
acceptable solutions to the grievances and problems of national

minorities is likely to grow in importance and in dire consequences for international growth.

Despite the extremely complex nature of this likely development and the ideals and requirements of national unity and security so zealously sought by all multi-national states, as well as the overwhelming international consensus on meeting the needs of national minorities within the context of the present United Nations ideal of non-intervention in the internal affairs of states, the special commission of the U.N. General Assembly has recently seen fit or necessary to interpret the U.N. Charter as providing for the right of oppressed peoples or nations within multi-national states to employ force if required to obtain equality. The U.N. as a third party to disputes between nations within multi-national states has become the obvious focal point for the elaboration and construction of instruments for the protection of national minorities. Thus it is of salient importance for national minorites to realize and assist the U.N. in playing this role for which it is uniquely most suited. *Above all, Malcolm's fundamental teaching was that the problem of minority protection is primarily an international responsibility.* In Hajji Malik El Shabazz' own popular expression, he may have said, "You can't ask the fox to take care of the chicken. He will protect them from others and look after their needs,but not for their benefit but rather to assure himself of readily available meals." Thus, the Afro-American question must be resolved within the context of U.N. participation, international law, U.S. politics, and international and domestic struggle.

THE CHOICES

PROBLEM: Should Afro-Americans attempt to physically return to Africa?

RESPONSE: No. If Malcolm were alive, he would feel that whether or not Afro-Americans physically return to Africa is irrelevant. It is obvious that they remain an African people or nation in the U.S.. It is also true that their nation has developed cultural and economic links with other nations living in the U.S., particularly the Anglo-American nation or the Anglo-Saxonized generally white ethny of the U.S.. The Afro-American has learned much from this ethny or nation, and this ethny or nation has learned much from the Afro-American. Morally, the territory

of the U.S. belongs as much to Afro-Americans as it does to Anglo-Americans. Afro-Americans have the right to bring whatever civilization they choose to the U.S., as much as does the Anglo-American to bring exclusively European civilization. Therefore in order to plan realistically in relation to their long history in the U.S., Afro-Americans may first wish to choose future affiliations in relation to civilizations, and then in terms of peoples within the civilization chosen. That is, moving *not necessarily* geographically, but rather culturally, politically and socially, into a civilization that includes African civilizations and will permit their full development.

There are essentially three non-geographically-limited civilizations in the world today: *western* (Christian, capitalist), *socialist* (communist), and that most recently to awaken, *Islamic.* The U.S., western Europe and all Anglophones or English-speaking countries belong to the culture and interest of the western civilization. Also the black minority in the U.S. and many Third World countries are presently included in that civilization. However these Third World people were generally brought into western civilization against their will by conquest, or by slavery as is the case with the black minority in the U.S.. Their relationship to the rulers of western civilization is primarily one of conqueror/conquered, exploiter/exploited, dominator/dominated, and thus they remain essentially integrated but unassimilated. They still have the right to choose their future affiliation, and since the end of the colonial period they have been exercising that right.

Socialist or communist civilization stems from western and possibly Islamic and slavic civilizations, but began as an effort to radically destroy the exploitative elements of western civilization. Over the past sixty years, under the direction of men like Marx, Lenin, Stalin and Mao Tse-Tung, etc., it has apparently succeeded to a great extent, and in so doing has created a new set of socialist values, a new culture and civilization. Many Third World countries, once a part of western civilization, have already joined this civilization and are in the process of reorientation.

However the vast majority of the Third World countries, including African peoples, remain uncommitted to western civilization or belong to the newly reawakening *Islamic civilization.* The heart and roots of this civilization is in Africa, the Middle East, Asia and the Far East, with significant influences and population in Eastern Europe. By becoming a part of this civilization, not only would American blacks build a

cultural bridge with the larger portion of African peoples, but they may also bring the Islamic civilization to the U.S., which would mean a great contribution to a pluralistically organized U.S. community of people, as well as assisting the U.S. to become more than just an Anglo-American, racist, unsympathetic country, insensitive to and uninvolved with the needs and welfare of the world outside of Europe, North America, Australia, New Zealand, white South Africa, etc..

JUST REFORM?

PROBLEM: Why not just struggle to reform the civilization in which Afro-Americans are? Must they introduce another civilization?

RESPONSE: Yes. Although Afro-Americans are presently physically within western civilization, and in general subjectively feel completely a part of that civilization, there is every proof that the free peoples of this civilization have never accepted Afro-Americans as members of their civilization. Instead, history seems to confirm that they see Afro-Americans as belonging to them, like possessions or tools that provide useful services. In other words, neither Afro-Americans nor their true heritage play any conscious positive role in determining what the U.S. is or will be, but instead it is the social, political and material needs of the Anglo-American nation that determines the Afro-American. An example of this is seen in the fact that even today, the U.S. is unable to officially accept the fact that its founding fathers were both African and European. It insists instead that they were all European, the Africans still seen as less human, belonging to the Europeans like material possessions. Malcolm suggested that this institutionalized attitude is as true today as if slavery had never been officially abolished.

What does this mean? For one thing, it means that the way Afro-Americans see themselves and the way the world, particularly the western world of which they purport to be a part, sees them, is not the same. *Thus, living to a large degree in isolation (in the black community) from equal status contact with members of the Anglo-American community, it has been easy for Afro-Americans to create the delusion that they are a part of this civilization composed of people who never know slavery* , because it was easy to feel a part

of the isolated black community in which they lived. Thus this was identified as western civilization, etc.. Of course, it was not and is not.

It is the interactions of people acting over the period, the substance and circumstances of their history that creates their culture, their civilization, not a legal declaration or proclamation. The Afro-Americans have over the past 300 years (the period of the rise and cementing of western civilization) been essentially the captives, enslaved or freed slaves, of this civilization, its possessions, signifying its African conquest. Are they a part of this civilization -- even though they may feel quite comfortable in the roles this civilization evolves for them? When did Afro-Americans arrive at any formal or nonformal social contract with the other peoples with which they have been associated?

The only way that Afro-America could become an equal status member of western civilization would be through the creation of a situation permitting it and the civilization it represents to enter into a social contract (equal status relationship) with other peoples of that civilization, and this could be done only through what Afro-Americans may consider "reform" but which the other members of that civilization would see as *national liberation* or struggle for *self-determination.* (The expansion of western civilization to include Afro-American civilization).

The problem with the concept of "reform" is that when it is pushed to the degree required to bring Afro-Americans as a group, people (not just individuals) with an African heritage, into an economic and social equal-status position, it would still mean their bringing socialism or Islam to America. *In the truest sense, national liberation or self-determination is the minimum reform necessary.*

TO STRUGGLE OR TO ACQUIESCE

PROBLEM: If Afro-Americans followed Malcolm, then it would necessitate a political or perhaps political and military struggle, which in either case would cause great suffering. Why not do like many of their foreparents did, and accept the status quo while pushing for *better treatment* rather than equal status or functional equality?

RESPONSE: Afro-Americans must struggle because even to guarantee the maintenance of the relational status quo and *better treatment* requires the Afro-American community or nation to increase

Its centralization of political power over the resources and people in its own nation or community. For example, the political power to raise taxes from the community and for the community, and the power to share Afro-American tax money with the federal government, is badly needed in order for the Afro-American community to deal with much of its present and future social and economic development. In order to achieve this greater centralization of political power, the community must demand a significant degree of political autonomy or independence from the Anglo-American community. The demand for this greater degree of political autonomy or independence would be resisted, and of course require struggle. *Therefore, even to guarantee the maintenance of the status quo and better treatment, the Afro-American must engage or continue to engage in struggle.* Otherwise the relational status quo and treatment will change according to the needs and whims of the Anglo-American community, as has historically been the case.

Moreover, if Malcolm X were alive, he would also insist that the most important reason to fight inequality and oppression is not just material but transcendental. The Quran teaches that if necessary, death is preferable to enslavement or oppression. To Muslims, this teaching can be accepted as an article of faith, but to non-Muslims (the majority of Afro-Americans today), the profound and practical reason behind this Quranic teaching should be made clear. For nothing good can come from the willing acceptance of oppression and enslavement. It can be demonstrated that more than twice the number of Africans died because of their acceptance of slavery than would have died in a struggle against enslavement. Also the oppressor did not become a better people or nation due to African non-violent acceptance of enslavement and inequality, but instead the U.S. became one of the most insensitive nations in the world to the needs and plight of non-European and non-Anglo peoples. As Malcolm would say, the acceptance of evil begets greater evil. Thus the Afro-American acceptance of inequality and enslavement has not only served as the human capital and original resource through which was brought into existence the world's greatest military, technological and social world power, but it is also a chief cause of the U.S. being a nation that insists on the feasibility of using its power for the worldwide benefit of maintaining the Anglo-American ideology of "white racism," oppression and exploitation of the non-European

and non-Anglo-American world at a point in history when such notions are clearly passé.

Thus the acceptance of inequality, enslavement and oppression by the Afro-Americans was not just an historical event or accident of concern to them alone, but an historical tragedy for most non-European or non-Anglo peoples of the world, on whom its negative ramifications are far from over. In addition, the acceptance by the Afro-American people of enslavement, oppression and inequality is largely responsible for a racist distortion and delusion in the American societal development. Afro-Americans must fight with the patriotic purpose of ending this distortion. Afro-Americans must fight to guarantee a future for their children, and last but not least, Afro-Americans must fight in cooperation with other oppressed in the world to help maintain a favorable equilibrium in the world of good over evil, of freedom over oppression. Afro-Americans must fight to reassert their humanity, and simply because they are oppressed human beings.

THE AFRO-AMERICANS AND THEIR INTERNATIONALLY-PROTECTED HUMAN RIGHTS

PROBLEM: Who is an Afro-American?

RESPONSE: Afro-Americans (according to Hajji Malik El Shabazz) are that community of people sharing a common historical heritage that has evolved out of the enslavement of Africans in the United States, and consequently sharing a common culture. Malcolm attempted to avoid using the word "Black" to denote Afro-Americans because he realized that the designation "black" carries no historical or cultural denotation requiring the acceptance of our African heritage. He realized that there were black Anglo-Saxons[1] as well as white Anglo-Saxons culturally and that both were enemies of the masses of blacks who wish to maintain their African heritage or a separate ethnic identity. Malcolm also noted that the Afro-American nation was composed of various shades of African, and that an emphasis on just the black pigmentation would not only permit black Anglo-Saxons to

[1] *The Black Bourgeoisie* by E. Franklin Frazier, Free Press, 1965.

continue in leadership of Afro-Americans but it may also act as a subtle effective method of creating salient divisions among Afro-Americans themselves.

PROBLEM: Does anyone know where the enslaved Africans came from in Africa?

RESPONSE: Yes. The African states as defined today are not the same as they were during the pre-colonial era. There were pre-colonial empires, not nation states. Thus both German and French anthropologists have determined that the vast majority of Africans sent to the U.S. came from areas that were once included in the *Ghana, Mali and Songay empires* of Africa.

PROBLEM: Scientifically speaking, is the Afro-American culture the same as the Anglo-American culture?

RESPONSE: Scientifically speaking, anthropologists have discerned that the Afro-American culture is a unique African culture greatly influenced by the Ango-American culture, and that over time it has adopted many Anglo-American values and habits, etc. similar to the way cultures in Africa have adopted various European values and habits. However it still remains uniquely Afro-American and is different from any other African culture similar to the manner in which Ethiopian or Moroccan culture is different from Nigerian culture or Nigerian culture is different from Ghanaian culture, or Ghanaian from Congolese, etc..

PROBLEM: Are there any politically and socially significant differences between Anglo- and Afro-American culture?

RESPONSE: Yes. For example, Afro-Americans do not elect their real political leaders (Dr. Martin Luther King, Jr., Warid Muhammad, Louis Farrakhan, Jesse Jackson, Marcus Garvey, The Honorable Elijah Muhammad, Hajji Malik El Shabazz, Imari Abubakari Obadele, Robert Williams, etc.). They come into position through their personal organizational and moral strength and charisma. Also, socially, Afro-America is often divided not only along class lines, but also caste lines based on degree of skin color and type of hair, degree of

assimilation and family heritage. Historically this division is often epitomized as the difference between the House Black and the Field Black. Further, Afro-Americans have probably developed a single parent family system as well as the two parent system due to the historical culture operating in an environment of socio-economic oppression. Like their counterparts in other parts of the world, they place significant value on "savoir faire", social exchange, physical and spiritual health, and jole de vivre. Their preferences are as correct for them, given their historical culture and circumstances as the Anglo-American family and lifestyle is correct for them, given their different historical and cultural circumstances. To support the Afro-American struggle means to support the right of the people to be different in the way that their culture and circumstances have made them at the social, psychological and political levels. The Afro-American should not be evaluated by Anglo-American standards and Anglo-Americans cannot be evaluated by Afro-American situations. The monkey-see/monkey-do evaluation standards of the current negro leadership must be abandoned by any means necessary. New standards must be developed through an empirical examination of the real customs, habits and ideals of the people. Whatever problem may exist must necessarily lie exclusively in the leadership because it is the leadership's responsibility to represent the interests of the masses, whatever that may be.

> *Six men fell every six days down six flight of stairs*
> *And broke their necks in six different places*
> *For six thousand years --*
> *Because of six unsuitable steps --*
> *And no living soul cared*
> *Because it wasn't them.*
> *It was only those who were not careful...*

(Those who did not do as the Anglo-American ethny prescribed.)

PROBLEM: What is meant by internationally-protected human rights, and are they politically important?

RESPONSE: These are those rights for which, if violated by the U.S., the Afro-American community can successfully demand international

assistance for redress. These rights are politically important because they include the following:

1. The right to be different

2. The right to be recognized as a nation or national minority

3. The right to political independence or self-determination if equal status cannot be achieved any other way.

4. Also, according to the special commission of the General Assembly of the U.N. on the law of peaceful coexistence, the right to wage an armed struggle to obtain the above rights if they are denied.[1]

REVOLUTION AND NATIONAL LIBERATION

PROBLEM: Is there a difference between revolution and national liberation?

RESPONSE: Yes. Revolution involves the entire society in question, and always means rapid institutional, social, political and economic change, while national liberation usually involves only a group or nation within the entire society involved, and may or may not involve rapid social and economic change. For example, when Algerians were considered as French citizens, the Algerian *national liberation movement* successfully demanded the total political independence of the so-called Algerian French from the other French. They succeeded without bringing about a revolution in France. This has been the case with almost every Asian and African people claiming the right to statehood at the conclusion of the classical colonial

[1]Milan Sahovic, ed., *Principles of International Law Concerning Friendly Relations and Cooperation*, 1972.

period. A similar struggle taking place today is that of the British people of Irish descent vs. the British people of Anglo-Saxon descent. However, for a people to demand national liberation, it usually means that rapid or slow revolutionary change has taken place within the ranks of the people asking for national liberation. This is true although the revolutionary orientation may have been compromised, delayed or defeated in the struggle to obtain self-determination or political independence. Thus, a revolution must occur in the political institutions of the oppressed in order to effectively effect self-determination through national liberation or political independence. This simply means that the responsible leadership of people in need of self-determination must unite and replace the irresponsible leadership opposing self-determination by all means necessary. Also, occasionally the success of a national liberation movement within the oppressed nation may ignite a revolution within the oppressor nation. Since revolution either within oppressed or oppressor nation must occur to have national liberation, the most significant of the two terms to understand from its universal perspective is revolution. What is revolution?

We have often heard the word revolution, and when we reflect on the historical usage of the word, we immediately realize that no one revolution has succeeded in bringing about the ideal system or set of conditions. Instead, history demonstrates that revolutions are followed by more revolutions. Why? Revolutions have resulted from the efforts of the people to realize their ideal, as understood through their prophets, current moral convictions and religions. In the most fundamental sense, it is the continuing effort of the people to fulfill the mission of their continuously changing material and spiritual needs, culture, and ideals that causes revolution. Although this statement may at first appear to de-emphasize the obvious materialistic and social causes and be an oversimplification, consider for a moment the fact that in all countries throughout history, there have always existed two basic laws: written and unwritten laws -- laws written by governments, and unwritten norms, ideals, religious beliefs, needs, etc. that the peoples of a given country believe to be ideal, such as fair distribution of wealth, human equality, the right to work, etc.. The more governmental laws and actions conformed to the ideal norms, the better would be the chance for survival of that government (ruling class or elite). The more the laws of government (or the ruling class)

deviated from the norms of the people, the greater would be the risk of revolution. Indeed, revolutionaries always appeal to the natural ideals or beliefs of their people in order to effectively oppose the officially-sanctioned, government-made laws and structures. This was the case with both Martin Luther King and Malcolm X. The force and general undefined nature of these natural ideals or laws or norms is such that governments are challenged to prove that they are attempting to have them implemented and upheld. This was particularly obvious when Martin Luther King, Jr. challenged the Black Codes of apartheid as being against God's law and Malcolm upheld the right of self-defense as in keeping with God's law.

When governments or leadership elites fail to convince their people that they can implement such ideals within the range of acceptable possibility, a revolutionary situation usually results. The revolutionaries are then supported by the majority in an effort to better implement these ideals. The revolutionaries do their best, until time, scientific, technological, and societal development outpace governmental structural change. These circumstances then produce a new revolutionary situation and others who convince the people that they can do better. Eventually, however, the process is again and again repeated.

Thus the revolutionaries are simply those who, in history, periodically appeared with a better or more convincing method for the implementation of the people's norms, ideals, material needs and beliefs, as found in the current beliefs and natural law of a given people and the progressively changing international environment. The essence of natural law itself is seen as having its roots in the belief system or the religious ideals of the people. Revolutionaries, in the most fundamental sense, are simply those who promise to fulfill the dreams, hopes and desires of the popular prophets. Thus, the final revolution itself can only be achieved when or if it is possible for the people to be governed only by their continuously changing natural laws and belief system fundamentally influenced by material needs. If this were possible -- this wave would be the *last revolution!* -- the coming of Christ, the return of the Mahdi, the Tao, the end of the world, Youm El Din.

When brother Hajji Malik El Shabazz applied this universal logic to the situation of the Afro-American nation, he realized that first of all the Afro-American revolution would be just one of the series of revolutions

that the new circumstances of this epoch would initiate, and that its initiation would be not only completely natural but probably inevitable. He also realized that it would have to be initiated, encouraged, completed and institutionalized. This is why he created the O.A.A.U.. It was to become the institution for encouraging that revolution, and he felt that the O.A.A.U. would eventually have to demand the right of self-determination, national liberation or some form of political independence. His efforts to bring the Afro-American question to the attention of the U.N. was to meet these eventualities.

Hajji Malik El Shabazz realized that the Afro-American nation was not politically monolithic,and instead was composed of many sincere revolutionary groups coming from different backgrounds, to whom self-determination or political independence would mean the obtaining of slightly different objectives. *That is why the O.A.A.U. was to be uniquely a political (not ideological) institution* and a political tool by which all revolutionary elements could unite in cooperation *to first replace the irresponsible traditional negro leadership*, second bring the Afro-American question to the attention of the world, third demand self-determination, fourth enter into national liberation struggle *if necessary*, and lastly, once the liberation struggle was won, to negotiate their differences in relation to the desirable type of society to create,and the new political, social and economic relation or contact to be sought with other Americans. This is why Hajji Malik El Shabazz had so much difficulty integrating the Muslim Mosque Inc. into his problematic, as well as his own personal belief in the Islamic society. Ultimately he reconciled the difficulty in his sincere belief that in the process of struggling for liberation and once the Afro-American people were free to make a choice, the choice of Islam would be highly probable. If they made a choice other than Islam, it would still be Islamic for him to encourage them to make a free choice between Islam and Christianity. There is no compulsion in Islam. At present Islam is growing faster in the U.S. than in any other country except France. In any case, Malcolm believed that only God decides who becomes muslim.

Hajji Malik El Shabazz also knew that a highly successful Afro-American struggle for national liberation might kick off a general American revolution. He was prepared to cooperate with the leaders of such in the event it occurred, for the benefit of all parties and the well being of the American peoples. This is one reason he

often attempted to understand socialist terminology. He believed that the principles of mass participation and collectivization or socialization of the essential means of production would naturally be a part of any revolution or national liberation movement that may occur. Hajji Malik El Shabazz knew that the demand for a black nation could only be meaningful if it assisted the U.S. peoples' development by solving the fundamental contradictions in American society and was just to all concerned, particularly the Afro-American masses. Furthermore, in order for it to be seriously accepted by the American peoples and potential international allies, it had to create a better situation and circumstances for the people it professed to represent than that which they presently had. A black nation for the sake of a black nation, or for Afro-American chauvinistic interest, would be meaningless, particularly to the masses of black Americans who have suffered most at the hands of black marionettes who have shown less concern for their humanity and needs than their Anglo-American oppressors.

The O.A.A.U was thus designed to begin a serious process by which Afro-Americans could progressively develop a program of action acceptable to them and in line with the progressive development of the international world to which they would eventually have to turn for assistance *in a way similar to the way the blacks in the Southern (Confederate) states had to turn towards the direction of the international world or northern states in order to achieve the ending of southern slavery* . The O.A.A.U. was to exist as both a domestic and international organization with headquarters in the States and branches outside – similar to the ANC, the FLN and all other modern political tools or institutions devised for self-determination, national liberation and possibly the internationally-protected right of peoples to armed struggle *if absolutely necessary.* If so, the precise meaning of self-determination or national liberation as it concerns Afro-Americans would necessarily be defined by the masses through the O.A.A.U. in the process of struggle, and not imposed from outside the uniting process by revolutionary elites. It would be uniquely a decision of the people or the struggle or it could not be maintained or endured.

THE BLACK BOOK:

UNITY

PROBLEM: Malcolm's political theory, no matter how correct or necessary, can't be accomplished without unity among the approximately 25 million Afro-Americans. Even Malcolm recognized the diversity within this group. No leaders in the past have succeeded in unifying them outside of a government or majority supported or approved program. So how would Malcolm X have viewed this problem?

RESPONSE: First of all, Hajji Malik El Shabazz came to realize that the problem of unifying the Afro-Americans for national liberation outside of an Anglo-American supported or approved program was in the western sense strictly a political problem as opposed to an ideological or religious one, and thus required a strictly political solution. That is to say, he realized that once the appropriate distinction between national liberation and revolution was clarified, the problem of encouraging a national liberation struggle is not one of getting everyone to share the same ideology, morality, class awareness, etc., but rather one of getting Afro-Americans with differing ideologies, moralities, class status, etc. to share the same goal of self-determination.

He realized also that this could only be accomplished when a popular leadership group, combination of groups or alliance of groups accepts in common and at minimum the need for some form of self-determination or political autonomy. Once this occurred and reached sufficient popularity among the masses (which is probably occurring today), this leadership group, combination of groups or alliance, like all other national liberation groups, be it the PLO, ANC, FLN, IRA, etc., demonstrates their popularity by making it impossible for any other leadership group or alliance, government- or non-government-sponsored, to credibly represent themselves as spokesmen for the Afro-Americans, at home and particularly abroad without the direct or indirect consent of the leadership group, combination of groups or alliance that has the popularity to achieve this goal. (The centralization of national power, influence and force)

This must be accomplished by any means necessary, and usually involves fierce inter-group struggles. The inter-group struggle is the first step of the struggle for national liberation, -- thus the inter-group

struggle for the centralization of national power is the beginning of national liberation. However, once one group, combination of groups or alliances wins out, political unity is achieved, and political unity is all that is required, because only in this manner is unity achieved and the popular will expressed where the Anglo majority holds the Afro minority in a situation of oppression and domination by the superior availability of force, wealth and influence.

AN ARMED STRUGGLE FOR SELF-DETERMINATION OR NATIONAL LIBERATION?

PROBLEM: But if Afro-Americans did decide that armed struggle was required, could they win?

RESPONSE: Yes. It is quite probable that if the Afro-American masses decide to fight, they will obtain their goals. *The more difficult question is whether or not the Afro-American masses will choose, if necessary, to exercise their internationally-protected right to armed struggle* . Of course, those who wish to maintain their oppression realize the intimate connection between the two questions. If they can be held to the belief that if they fight they cannot succeed, then the choice to fight can be mentally controlled. Thus, the struggle is lost before it begins, and their situation becomes totally predictable and subservient. Simply stated, if they wish to take a direction which the oppressor does not desire, he need only show that they must fight to follow this chosen direction, and like herds of sheep or cattle, they will only choose a path acceptable to their oppressor. Such a situation, which enslaves the human will, is unacceptable and it is absolutely contradictory to the requirements for political equality, human dignity, freedom or any kind of equal status.

In the past 300 years, the Afro-Americans lived in a world almost completely controlled by the Anglo-American and his social, economic, political and military western European allies. Thus all Afro-American efforts at armed struggle in the past, except when in cooperation with the northern Union U.S. armies against the Confederate states, were pitilessly stamped out. Based on this historical record, it has been easy for the oppressor to convince the Afro-American that the same situation exists today, and to create a

deep-rooted fear in Afro-Americans of armed struggle under any circumstances.

However it is clear from the successful armed struggle of the oppressed all over the world, including that of South Africa and the insurrections used to assist Martin Luther King, Jr. (parts of every major American city were set on fire) that the situation today is not the same. The oppressor and his allies no longer hold a monopoly on the use of force and the availability of weapons. *Today national liberation struggles are won simply because the oppressor is unable to stop the oppressed from continuing an armed struggle whose continuation would cost much more to the oppressor than the benefit he receives by not giving the oppressed political independence, autonomy, equal quota representation, non-segregated schools, the right to collect a share of community taxes, etc..* For example, when parts of U.S. cities were being set on fire, we might say that the cost to the U.S. in dollars, in loss of internal harmony, in GNP, in international power or capacity to influence, etc., was much greater than the benefit received from the maintenance of official segregation -- thus down went official segregation. As a matter of fact, Martin Luther King, Jr. or the Afro-American traditional leaders could have asked for much more (including some form of political and economic autonomy), but they chose to settle simply for an end to official segregation. *After King's death, they gave the U.S. government (ruling classes) a very good deal -- probably as good as receiving New York from the native Americans for a necklace.* There is no doubt that the U.S. government would have given much more in order to return to domestic order and end the random destruction that was costing millions of dollars. Thus, when one asks if a just armed struggle will succeed, Malcolm would have answered that *one need ask only if a struggle can be sustained, and if its continuation will be more costly to the state concerned than the just demands being made by the oppressed.*

In the case of the Afro-American (Brother rabbit vs. Uncle Sam), it is obvious that the destruction and disarray Afro-Americans could create at home in the U.S. and abroad is far greater than the benefits the U.S. receives by attempting to maintain structures of oppression. Furthermore, should the Afro-American choose continuous armed struggle, the cost of maintaining the oppression itself would progressively rise while the benefits would progressively, over time,

decrease. Malcolm foresaw that *the question is not one of defeat or victory but one of cost and benefit.* A rational government as old and experienced as that of the Anglo-American and their allies will not exchange a million dollars for a dime: the continued oppression of a people at the expense of the Anglo-American way of life, international position, internal harmony, senseless loss of life, and the breakdown of the American international and national political, social and economic systems.

However, El Hajj Malik El Shabazz realized that the swift and unprecedented increase in the pace of development in the science of propaganda and in technologies in this century has created a situation whereby governments like that of the U.S. have at their disposal an awesome array of scientific conceptualizations, scientific techniques, military hardware and other devices that can be used to maintain the status quo. Thus the level of sophistication of the successful armed national liberation struggle and its leaders of our day is a far cry from the "rabble rousers" or statesmen soldiers of the recent past. Successful national liberation leaders such as Nelson Mandela, Kwame Nkrumah, Gamel Abdul Nasser, Mao Tse Tung, Ho Chi Minh, Sekou Toure, Ben Bella, Ayatolla Khomeini,and Daniel Ortega, etc., regardless of one's personal belief or non-belief in the systems they represent, were above all good political scientists (political engineers). The rising level of political sophistication of modern national liberation leaders is a testimony to the increasing sophistication of the techniques of oppression. This obviously implies that a nation or society that does not develop a high level of popular political sophistication will be unable to succeed in an armed national liberation struggle. *Likewise, it suggests that governments may lessen the chance of national liberation by maintaining the popular masses at a low level of political sophistication.* This is the case in the U.S., where political science was only recently taught to Afro-Americans, and where Baptist-trained religious leaders or constitutionally-oriented lawyers trained within the Anglo-American legal system have been the main people to enter the political arena.

Today national liberation no longer occurs haphazardly. Today when a national liberation situation exists, it is not automatically transformed into actual liberation. With the support and under the direction of the masses, the situation must be understood and the transformation encouraged by a revolutionary intelligentsia. In

organizing the O.A.A.U., Malcolm presented a fundamentally modern view of the role of national liberation in human societal development. He dared to view the national liberation and revolutionary potential in the U.S. situation while emphasizing that national liberation or revolution can only result naturally from a real-world situation and not from an analysis of that situation or the self-righteous desire of a political elite to organize or impose their revolution on the masses.

Of equal importance, the events in Malcolm's life and those leading to his death emphasized not only revolution and national liberation as an historical developmental process, but also its meaning as a living reality -- its horrors, its benefits, the necessity and tragedy of national liberation or revolution as a human historical process of development. He knew that hope of a nonviolent future lies not in attempting to block national liberation and the need for societal development, but in recognizing the fact that revolution and national liberation is as much an actor in societal and human development as education, and may be essential in eventually creating the mechanisms and societal and political apparatus that will permit non-violent change or rapid structural change necessary for a healthy national development. There are already indications that such countries as Sweden, Greece, Spain, etc. have grasped the essence of this reality and begun to create the climate and institutions to permit the possibility for non-violent or less violent national change or revolution. The daily accepted functioning of such revolutionary parties as those of the communist left in these western countries suggests that Malcolm's concept of revolution as a developmental process may be in the process of being tested.

> To be human is to choose -- to reject or accept
> This human quality is the door to revolution
> or repression -- To life and death --
> The criteria for good and evil
> The penance and the reward.
> The final act of will --
> Thus, the fulfillment.

THE ROOT OF AN ARMED NATIONAL LIBERATION STRUGGLE

PROBLEM: Is it true that an individual or organization can make a revolution or bring into existence an armed national liberation struggle? How do revolutions or armed liberation struggles occur?

RESPONSE: Malcolm believed that national liberation struggles have always been a part of human historical development, the same as the periodic disasters of Velikovsky's nature have absolutely changed the course of rivers or the location of mountains, or more predictably, as the summer relatively quickly becomes winter, and winter summer. The realization that revolution is a natural part of human history, and perhaps the human condition, leads us to search for the basic factors in societies, nations, empires or states that can be considered the prime cause of all revolutions. As before mentioned, this is found in the existence in each organized nation state or multinational state of two power-based sets of laws. One we called the ideas and actual beliefs and needs of the people (the power base being latent in the potential of the majority) and the second is the written laws of the ruling group, clique or class of that society or state. The power base of the latter is immediately effective and is usually manifested in the institutionalization of a visible enforcement mechanism, be it the police, army, etc.. The social contract between these two power bases is always understood in such a manner as to legitimize the enforcement mechanism of the ruling group insofar as they are perceived to act in the interest of the ideals of the majority. This action must always be perceived in terms of being against the selfish interest of an individual or individuals (that is, against the interest of individuals and sub-group minorities who are considered an integral part of the society concerned. This does not include ethnic minorities who are not considered an integral or assimilated part of the majority ethny.) In the past, and in international law, ethnic minorities have more often been considered nations or groups within themselves. If they were a minority within an empire of other ethnic groups, the ruling groups of such empires usually were involved in a separate social contract, written or unwritten, with such minorities. *If such an ethnic minority was not a party to some form of social contract with the rulers of the state in which it lived, it was considered a conquered or captive*

people, in which case it was usually in the process of struggling for an acceptable social contract or its national liberation.

When the ideals (wrong or right) of a people are relatively the same or are perceived by the majority to be relatively the same as their written law, there is no revolutionary potential in the masses. However, when the ideals of the people and that of the ruling group differ greatly or are perceived to differ greatly, the revolutionary potential of the masses increases. If the ruling group cannot convince the people that they are upholding the ideals of the people, or are doing the best possible under the given circumstances to uphold these notions, revolution is probable.

In a fundamental sense, then, revolution is caused by changes in the ideals, beliefs and material circumstances of the people, in circumstances wherein the written laws or policies of the ruling elite do not or cannot change to accommodate such changes in the ideals and material circumstances of the masses, and where the ruling elite's understanding, education or propaganda cannot convince the masses that they are upholding the present ideals of that society as best possible. At this point, new societal elements become politicized and promise that they will and can better uphold the ideals created by the new political and material circumstances. Revolution and/or national liberation occurs, the new elite is supported by the majority, until the ideals, through the changing political and economic circumstances, education and technology of the masses, again change, and the process is repeated. Marxist-Leninists suggest that the process will be repeated until technological progress and the socialist educational process create a situation whereby the majority themselves (the workers) will control both their material circumstances as well as the law of the societies (stateless society). The Islamic civilization suggests that not only must the workers have this control through the societal submission to the one just God, but that mankind will continue to develop toward the perfection of its submission to the will of God. In essence this means that affairs of state must be under the guidance of those the popular masses find to be the most righteous, and their position is dependent solely on obedience to the will of God and the people's ideals. The western liberal ideal suggests that the process should stop when democratically-elected ruling elites, responsive to the demands of the masses even against their own personal class interest, evolve. Thus for the latter, the masses by

definition can never represent their own best interest nor can these interests be governed by the popular ideals but rather must be governed by elected representatives. Obviously recent history disproves the liberal conviction of the value or certitude of revolutions not proceeding beyond the liberal bourgeois representative framework. However, though the Marxist-Leninist's present day socialist concept of mass representation through party control broadens the base of mass identification with their ruling representatives, it leaves many questions still unanswered, and the problem of future development unaccounted for.

It is important in understanding the root of revolution to understand that the revolutionary or national liberation leaders are no more than they who propose to uphold the ideals of the people, often the same ideals that the ruling elites purport to uphold. In an ideal situation where wealth and arms were evenly distributed and there was no outside interference with a people, nation or state, the vast majority could always decide through the mode of armed or non-violent conflict who best represents those ideals. In the ensuing conflict, the true revolutionary in a revolutionary situation would be the least anti-social or criminally orientated (in the de facto societal and moral sense.) Also in such a theoretical situation, the anti-revolutionary ruling elites may feel (although it is more often not the case, particularly in Third World countries) equally moral in that their education, class interest and background has led them to believe that the majority demands and opinions are not best for the majority. But their political education and orientation, grounded upon elitist philosophy such as that of Plato or Aristotle has become obsolete due to objective changes in material, educational and social circumstance and the advancement of technology.

THE IDEALS OF THE PEOPLE

PROBLEM: What is meant by the ideals of the people?

RESPONSE: When Malcolm spoke of the ideals of the people, he referred to the continually changing, very flexible and reality-adaptable set of rules and principles *springing spontaneously from the religion*, education, material circumstances, cultural and pragmatic belief system of a given population under given circumstances at a

defined point in time. Often, as is the case in devoted muslim communities, the total ideal is summarized in their religion. If the society were so organized that such rules and principles were permitted to directly form the core of societal written laws and codes, such written laws and principles would necessarily vary from society to society and through time, in keeping with the changing consensus of the population concerned or in the case of muslim communities, in keeping with Quranic guidance or the will of God. This notion differs from the theory of written laws and principles only inasmuch as such laws and principles fail to conform to the popular ideals and norms, or lag behind and fail to keep pace with the consensus of the masses. This occurs probably because of the tendency of law to reflect and support the interest and profit of the ruling elite. It is this tendency of the written rules and principles to lag behind the ideals, needs and circumstances of the masses in the same nation or the imposition of the rules of one nation on another for the purpose of domination and exploitation that initiates circumstances which permit the process leading to a revolutionary situation or a national liberation struggle.

PROBLEM: Are there different types of revolution or armed national liberation struggles?

RESPONSE: The types of armed national liberation struggles or revolutions since 1945 can be classified into four broad categories according to their most salient motivating factors (the salient ideological paradigm propagandized to the popular masses concerned).

Nationalist or National Liberation (without revolutionary change in the institutions of the group liberated)

These revolutions are the most numerous following the political end of the colonial period and the direct and overt application of the colonialist ideology. Such revolutions resulted in the establishment of many new states in Africa and Asia and greater political autonomy for certain minorities and ethnic groups. They were fueled not only by the popular realization of the exploitative effects of colonialism and imperialism, but equally by the introduction of the ideas of the nation-state, ethnic consciousness and the will to survive. An additional factor

was often the realization of the local ruling elites or classes that they would benefit more by obtaining greater political and consequently economic control over their local populations. However, as we well understand, there were many more contributing factors involved and all the contributing factors were interdependent.

Socialist and Communist

Here we should remember that "socialist and communist" are not used to describe the type of society actually established nor to indicate the exact ideology of the ruling elites who led such revolutions, but to refer to the ideological ideas that motivated and were popularized among the masses. It is quite possible to understand that in the revolutions popularly motivated by socialist/communist ideology, the ruling (revolutionary) elite may have actually been nationalist-oriented, using Marxism as a means to achieve national goals. Equally true would be the assumption that in certain instances, the masses acted from both nationalist and communist motivation. However in all such revolutions, the essence of the popularized idea was that of equal distribution of wealth, status and social, economic and social opportunity through state control or ownership of the means of production. The communist/socialist revolutionary leaders were equally endeared to the notion that social and economic development could be essentially rationalized and thus could be planned, etc..

Due to the position of the U.S.S.R. as a major world power, as well as the existence of unequal distribution of wealth in the Third World, the mass motivating qualities of the socialist/communist ideologies are presently playing their most important role in encouraging revolution, and as a result, future revolutions are likely to become increasingly orientated toward socialist popular democracy. If we remember that it is ultimately changes in the ideals and circumstances of the people outpacing changes in governmental structure, institutions and conceptualizations reflected in the written laws that produces revolutionary situations, it becomes easier to understand that socialist/communist ideology accepted by the masses would necessarily take time before effecting such real institutional changes. Thus it is clear why many (so-called) revolutionary elites did or were able to opt for nationalist solutions after having generated mass

support for the national liberation on the basis of socialist/communist ideas, and why after the "success" of their political liberation, the revolutionary fervor of the masses continued. The answer is simply that there was no revolution. The colonial power acted, in turning over power to the local elites in time, to prevent the revolution. The socialist/communist ideals accepted as articles of faith by the majority fighting for national liberation were not defined by that majority in terms of the every day functioning of government and societal institutions. So when the elites took control of the newly liberated state, they were able to define whatever institutions established as being progressive, or socialist, or indicative of a march towards socialism.

Reawakening Islam

Recently a third ideological force has begun to initiate revolutionary fervor in the direction of rapid change. The Islamic force tends to act against nationalism as introduced by western European development and socialism as introduced in the development of the U.S.S.R. and China. It is both anti-nationalist and anti-materialistic. If politics is considered, as in western thought, as separate from the religious and social development, then it may be considered anti-political. However, Islam does not separate the political from the moral or religious. All aspects of societal life are viewed as an integral part of the whole, the din, the one God. Thus all aspects of life in the state must be harmonized so as to achieve spiritual peace, happiness and total submission to the will of the one God. Both the governing elite and masses are equalized and/or governed by rules and principles from outside of society (the Quran and sunna). The rules and principles emphasize the well-being of the human being above all else, including production and technological advancement. While production and technological advancement are not the controlling criteria of the society, they are seen as important and essential inasmuch as they serve the interest of the well-being of mankind. Thus religio-socio-politico-economic factors of life in society are to be blended into a harmonious and non-contradictory way of life. It is both anti-capitalist and anti-communist. Because it does not limit its appeal to the political and economic organization of society but also focuses on the social and spiritual organization, it is naturally strongest among people who seek non-materialistic

developmental change rather than the maintenance of the status quo. Though often considered anti-western, it favors neither the East nor the West, but a set of principles and morality wherever it is geographically found. It appeals to masses on the basis of a return to the structuring of the world according to a progressive socio-economic and political criterion derived from the Quran and hadith of the Prophet Mohammed (PBUH). Since many western and Third World people still adhere to such criterion, and because many more western and non-western people have become disenchanted with the western socio-economic and political heritage of materialism, the Islamic revolutionary philosophy exerts a motivation toward rapid change through its emphasis on wholistic development, on human contentment as well as output, or the here as well as the hereafter. Its' anti-nationalism, in a world where many groups and individuals have suffered because of identification with a nationality, and in a world order that seems to have no solution to the potent problem of ethnic oppression, gives it a special appeal to the modern anti-ethnocentralist, anti-racist consciousness of the masses. Of course, its' appeal to co-religionists to regroup into a new socio-economic and political unit has its strongest immediate revolutionary influence among muslim masses and those seeking progressive change in the international status quo and its weakest influence among western and European elements that wish to support their undeserved privileges by maintaining the status quo by any means necessary. Lastly, the Islamic motivation also includes the concern for an equalized distribution of societal wealth. Due to the fact that its development had many geographically diverse historical centers -- Africa, Asia, China, India, Malaysia, Southern and eastern Europe, the Philippines -- it may be culturally accessible to the largest number of societies.

Humanism (The Third Universal Theory)

Humanism as a motivating force is used here to refer to the principal motivating agent in revolutions wherein socialism/communism, nationalism or Islam are not clearly the chief aggregating force. In such revolutions, some form of socialism is usually present, quite often nationalism also plays an important role, and often reawakened Islam acts in behalf of change. However the clearest single force is defined in terms of the happiness and well-

THE BLACK BOOK:

being of the masses. This chief general emphasis on happiness and well-being above the choice between available ideologies permits such revolutions to attempt the introduction of a mixed array of economic, social, political and religious remedies radically rearranged to favor control by the masses or autogestion. The concepts of popular democracy, self-managing societies, stateless societies, anarchism, the Third Universal Theory of *The Green Book*, etc. are all revolutionary concepts which have in common a revolutionary humanistic orientation. The question raised by this conceptualization is whether decentralization of power to this degree would not lead to political and economic disarticulation and disorganization at times when centralized guidance and authority may be required.

Points in Common

All modern revolutions or successful national liberation struggles can be said to have these chief emphases in common:

1. More equal distribution of societal and international wealth.

2. A definition of development more in line with human needs and aspirations.

3. Greater stress on intersocial equal-status relationships between members of societies.

4. Greater political control in the hands of the masses.

5. Less functional importance assigned to race, national origin and ethnicity.

6. Less separation between the military and the masses.

7. A renewed emphasis on the equal status of women in society.

8. A high degree of anti-Americanism (status quo) and a greater affinity for the U.S.S.R., China and the Third World revolutionary countries (change).

9. An antipathy towards economic and cultural imperialism, colonialism and neo-imperialism, and those existing institutions which tend to perpetuate Third World underdevelopment.

10. De-emphasis on individual human rights in favor of collective human rights, and the inclusion of individualism within the limits of collective well-being.

11. The creation of strong popular leaders who are able to govern effectively.

12. A view of technology as the most important and usable western European and colonial contribution to world development.

13. A view of the developed liberal democracies, particularly the U.S., as corrupt societies, although very attractive to individuals with the means to participate effectively in the corruption, to profit from the almost unlimited freedom to exploit which such societies afford.

THE REVOLUTIONARY INDIVIDUAL

PROBLEM: Does the individual as an individual play any role in bringing about a revolution or armed national liberation struggle?

RESPONSE: In a revolutionary situation, there exist numerous revolutionary individuals. The revolutionary individual such as Hajji Malik El Shabazz is the catalyst of the revolutionary situation though of course one does not exist without the other. As a matter of fact, the revolutionary individuals come into existence simultaneously with the

revolutionary situation, and it is the increase in revolutionary individuals that gives a situation increased revolutionary potential.

Most important, to Malcolm's viewpoint, is the fact that the revolutionary individual *does not come to be so because that individual chooses to accept or expound revolutionary ideology or actions* but rather because certain keenly sensitive and intelligent individuals perceive societal injustices to such a point that they are trapped in a situation wherein their personal morality and rationality is threatened by having to accept the injustices perceived. The result is the Franz Fanon concept of mental contradictions arising within the individual to the point whereby the rationality-saving way is to "act out" against oppression and injustices. The only way out of the dilemma then is national liberation or revolutionary change.

The revolutionary individual thus is nothing more than the product of environmental factors. He or she is a natural outgrowth of a situation wherein the peoples' ideals and the societal written law differ too greatly. After attempting to straddle these contradictory laws (supported by hope of reform), the revolutionary individual then finds himself mentally unable to envision a reform that is adequate to bridge the gap between the societal law and structures that are out of step with the desires and needs of the people. He thus declares the former unjust and unjustified, and falls back on the ideals of the masses to sustain his humanity and rationality. In this way, he is an automatically-produced potential intellectual, statesman or soldier of the people. According to Franz Fanon, if such an individual refused to reject the oppressor's institutions, he is likely to suffer from an unresolved mental conflict, or from some form of *serious psychosis*. The essential understanding is that a revolutionary individual is the natural product of a situation wherein severe collective oppression dominates, which he cannot accept, and he has no choice other than to become revolutionary or mentally ill, whether he realizes it or not.[1]

The revolutionary action and rhetoric of the revolutionary individual must not be confused with the "rap"olutionary action and rhetoric of the individual opportunist or bourgeois who adopts revolutionary posture and rhetoric calling for systemic reform in order to maintain an appropriate image before the oppressed masses so

[1]See James Foreman, *The Making of Black Revolutionaries*, Open Hand Publishing, Washington, 1982.

as to sustain his usefulness to the Anglo ruling element and share in the profits obtained by the condition of oppression. Such individuals are not affected by the societal contradictions because of either a lack of keen sensitive intelligence, a firm belief in the inferiority of the oppressed, mental illness, disintegration of the normal ego functions, or chronic moral corruption. The "rap"olution of such individuals serves as a smoke screen behind which the oppressive institutions, laws and structure of a society can be maintained.

Such individuals also create chaos in the societal development projects of both the oppressed and the oppressor in that they can neither accept the real useful aspects of western liberal democracy, or a clear alternative. They juggle ideas, misplace concepts, and thus assure that no worthwhile development, wisdom or change can occur in that state.

The revolutionary individual, however, seeks no recognition from the existing social structure, and thus is unlikely to be found vying for any high visibility institutionalized position of authority. *He is as likely to be found in the street, the prisons, the treatment centers, etc. as in the universities, executive institutions, etc..* He may be found anywhere. However, this does not mean that most revolutionary individuals have no influence. *They are unlikely to have influence derived from their job positions in the society which they do not accept. But they are likely to have great influence among their peers, the masses, who, like themselves, have no societal institutionally- defined authority.*

The revolutionary acts of the revolutionary individual are simply those legal or nonlegal acts which he performs against the interest of the unpopularly established social order in order to sustain himself, his family and friends, spiritually as well as materially ,and in his automatic, planned or natural reactions to the unjust nature of his situation and oppression as he sees it, not as told to him by a political revolutionary elite. The revolutionary individual can best define the social, economic and politically unjust condition of oppression that leads to his actions and situation in a way most meaningful to the masses concerned, since oppression is to some degree subjective and to some degree resulting from the subjective domination of the will and interpretation of action and behavior of one group or class over another. In a revolutionary situation, it is the will and subjective perception of the revolutionary individual that is important, a key factor, in defining the realities of the revolutionary situation. It is his

THE BLACK BOOK:

interpretation and viewpoint that, in directing the revolutionary, must
be rationalized and further supported and explained in relation to
current political thought by the central revolutionary thinkers or
intelligentsia. Due to the nature and circumstances of the revolu-
tionary individual, his view will always more closely ally with the interest
of the masses.

THE CENTRAL REVOLUTIONARY ORGANIZATION

PROBLEM: In order to have a successful armed national liberation
struggle, is it necessary to have some kind of central revolutionary
committee or organization of thinkers or an intelligentsia?

RESPONSE: Yes. Malcolm felt that the central revolutionary organ-
ization (no matter what it may be called -- the revolutionary
committee, the revolutionary council, the N.A.A.C.P., Muslim Mosque,
Inc., the ANC, FLN, FALN, RNA, O.A.A.U., PLO, communist party, etc.) is
always composed of politically trained or politically aware
revolutionary individuals (the central revolutionary intelligentsia) who
are different from other revolutionary individuals only in the sense that
their circumstances, situation, perspective or training permits them to
"act out" in a manner that conceptualizes the total revolutionary
situation and the need to *spread, maintain and win* domestic as well
as international allies for the actions of the oppressed masses, which
amounts to a revolution or national liberation struggle. Their actions
thus take the form of diplomacy and propaganda, both nationally
and internationally. *Their most important job is to explain the rationale
of any act taken by the revolutionary individual in the context of the
nature of oppression and the need for revolution or national liberation.*
Being directed by the masses and located outside as well as inside
the state concerned, they simply morally and politically defend and
thus encourage the acts of the revolutionary individuals. *They do not
start a revolution, fight it, win it, or decide the exact direction it will take.
Only the nature of the situation, the laws of nature, the world
environment and God can do this.* They simply act in such a manner,
at such a place and time, on such a level as to assure that the voice
and acts of the revolutionary individuals will not be suppressed or go
unheard, and will be associated with the need for national liberation or

revolution. If they succeed in doing this, the revolution will be brought into de facto and de jure existence, whereby in combination with internal good will and outside assistance it can be maintained. *Due to the nature and to the necessity of the revolutionary individual to operate under the most severe repression and oppression, his freedom of behavior or life style cannot be limited by any form of organization or idealism.* Thus the central revolutionary organization does not attempt to limit, direct or organize the revolutionary individuals until such a stage in the revolution when the revolutionary individuals begin to organize themselves around the central revolutionary organization, and ways have become available for them to seek material and informational assistance from the central revolutionary organization. *It should be emphasized that successful revolution is a completely natural process resulting from a revolutionary situation, wherein revolutionary individuals simply play the roles which they are in the best position to perpetually maintain until the revolution spreads, grows and is achieved.* Due to the anti-institutional, socio-political and cost-benefit nature of the national liberation struggle, Malcolm envisioned that the revolutionary individual at the soldier level is by necessity essentially concerned with: *What can be destroyed? What can be taken? How to get away?* (By any means necessary)

In contrast, revolutionary individuals who form the central revolutionary organization (revolutionary thinkers) are essentially concerned with the questions: *what, to whom, where and when must they speak in order to keep the revolutionary process in motion? To whom should the appeal on behalf of national liberation and the acts of the revolutionary individuals be addressed and formulated:* what segments of the oppressor group or class, the (external) enemies of the oppressor, the (external or internal) friends of the oppressed, the U.N., all or any combination of the above?

PROBLEM: How can the revolutionary individuals be encouraged to act in the cause or under the banner of the revolutionary organization? Can a better political system be propagandized within the context of the changing reality?

RESPONSE: Yes, but only at the latter stages of the struggle, after a political vacuum has been created by the removal of the government-sponsored traditional negro leadership. Only then is

there any space for new institutions or concepts among the masses. Only then will the masses take the idea of new institutions seriously; only then will they cooperate. Thus only then can new concepts and institutions be actualized, and only then, does the revolutionary organization's main concern become: How can the revolutionary individual be voluntarily brought under the direction of his own central authority? and What must be the political nature of that central authority? This is also a natural process since those who have been fighting will and must seek the collective representation of the organization that supported their demands if they are to benefit from their struggle. To say "it is natural" means it cannot be organized until it is demanded.

Of course, this is not to suggest that the individual members of the central revolutionary organization will not be committed to an ideology beyond national liberation, but rather that at the beginning stages of revolution, *they must have a political strategy and tactics as well as an ideology*. At the beginning, all emphasis is placed on encouraging the revolutionary individuals to destroy the institutions that serve to block national liberation and on the establishment of new recognized leadership, ideologies, concepts and institutions. Only when such institutions are being destroyed does the ensuing political vacuum guarantee the continuation of the revolutionary process. Like the revolutionary acts of individuals and the society itself, the revolutionary process is governed by the law of nature and the needs, ideals, desires and will of the masses, and not ideologies or theories. Ideology and theory are a guide for establishing a new socio-economic system after the revolution or national liberation struggle is won. Theories don't make revolutions. *We must trust above all and absolutely in the good common sense of the popular masses – that they will fight the way they understand and know for whatever objective they are willing to fight for. There will be national liberation only if they want it; the struggle can be maintained only because they will it, and it will bring into existence that for which they fought.* They must trust absolutely no one, and have faith only in the ultimate justice of God. In this notion, Malcolm's idea was quite different from the teaching of traditional political science. Understanding the political and economic laws and principles of society, which Malcolm saw as the law of God as proclaimed in the Quran, permits the revolutionary intelligentsia to avoid having to engage in reactionary questioning of

the people's longterm goals and objectives, of whether the people know what is best for them. The central revolutionary organization is simply the technician, the engineer, the strategist seeking to release the people from the psycho-socio-political bonds so that they may obtain their goals and objectives through protest or armed struggle, if necessary. In other words, *the CRO seeks to make free choices* between systems, ways of life, good and evil. The ideology and institutions of all societies evolved through the active participation of the popular masses, and the law and ideology of new societies will likewise come into existence. The revolutionary organization is part of the masses and thus a part of the masses' revolutionary developmental process. The realization of these facts permits the revolutionary organization to play an effective part in the social, ideological and political development of the masses.

Although this summary does not do justice to the difficulties faced by the central revolutionary organization, to go further would mean developing a theory beyond these notions that can be demonstratively deducted from the instructions to the O.A.A.U. and responses to the questions we asked the great American muslim martyr, Hajji Malik El Shabazz. However in concluding, we can see that Malcolm's ideas point to the need for a subtle and extremely high conceptual and intellectual development of the revolutionary thinkers in order for a class, group or nation to achieve the ability to create and sustain a national liberation struggle against a superiorly armed oppressor (Brother Rabbit vs. Uncle Sam). The changing relationship between the revolutionary individual and revolutionary intelligentsia, between the revolutionary intelligentsia and the oppressor, between outside elements and the revolutionary intelligentsia are filled with complicated problematics that successful revolutionary thinkers must be able to conceptualize and effectively resolve in relation to the ongoing reality of the society's material, social, political and psychological circumstances and the international environment. The inability of the revolutionary thinkers to do this indicates that the group or nation concerned has not yet developed to the stage whereby, under their circumstances and situation, a national liberation struggle is desirable or possible.

THE BLACK BOOK:

REVOLUTIONARY STANDARDS

PROBLEM: How does one deal with the question of standards, that is, the type of behavior and comportment to be expected of a revolutionary?

RESPONSE: For Malcolm personally, no doubt the question of revolutionary standards was embodied in the first portion of the statement he made (*Shahada*) when he accepted Islam: *There is no God but God...* Applying the logic which is intended in this statement (*Shahada*) to the question of standards in a national liberation struggle, we may conclude that no one should put their faith in anyone except God (trust no one, prepare for the worst and hope for the best). Thus personally, Malcolm would have upheld the need for a personal Islamic code of behavior. He would have followed the Islamic law (*sharia*) as it relates to questions involved in national liberation, war, struggle, etc. (see Introduction). However, *Malcolm believed that non-Muslim Afro-Americans would also, through struggle, come to understand the necessity for certain standards. Therefore, he emphasized above all the necessity to struggle .* One's personal standards would then be at a lower order of priority and should not be imposed on others. *God alone, through the various forms of struggle (personal, social, family, etc.) can impose standards on the masses.* What Malcolm was primarily concerned with in his interpersonal relations was sincerity and honesty. In attempting to create both the Muslim Mosque Inc. (personal and Islamic) and the O.A.A.U. (central revolutionary organization, CRO, non-muslim and muslim masses), he demonstrated that he realized that each revolutionary group, and sometimes each revolutionary individual would determine their own revolutionary standards, as they relate to personal behavior and comportment, in the process of just struggle. He realized that each revolutionary leader or central encouraging group (CRO) would only present the masses with an example of standards which may or may not be accepted.

Malcolm's often repeated statement *by any means necessary,* when analyzed in relation to the conflict of his time between the philosophy of non-self-defense (non-use of force, even if necessary to save life) and the philosophy of self-defense (the use of force for self-defense) and his acceptance of Islam could only mean that

personal behavioral standards should not be allowed, in any way, to discourage the masses from engaging in struggle, and that that struggle could involve measures for self-defense as well as non-violent methods. But above all, the highest moral standard is to struggle against oppression, because only in struggle can the masses be free to acquire truly moral standards.

We would interpret the foregoing to mean that in the present oppressive, distorted, contradictory and undetermined circumstances and situation of the masses, they, in the majority, cannot be expected to arrive at a consensus on standards of behavior without first struggling against their oppression. Such a consensus can only be created through the process of struggle, which is the only act that can dissolve the contradictions in their circumstances. Thus, to view the need for behavioral standards for the masses as equal to the need to struggle is reactionary and acts against the actual popular realization of the standards sought. As the masses engage in a just struggle, they will (using the ideals of the collectives) begin to evolve standards, first as individuals and groups, and as the struggle is hardened, the similar patterns of various standards evolved will form the basis for the conceptualization of standards suitable for the total collective or nation.

The essential understanding, as Malcolm might have said, before and above all, is to encourage the struggle, for this is the first and key moral standard.

The Soldier of Allah

A Black Hole, emerged
through the stars
on a dark, still night;
the moon was not in sight,
it hid in the lap of the sun
who sat over the Red Sea
awaiting the great landing
of the Black Hole.
As the Black Hole got nearer,
the earth began to recede.
The chase continued until the earth
reached its bottom.
The Black Hole was just about
to devour the earth,
but for short seconds
the night disappeared
and was replaced by a Sea of Light
out of which emerged a Black Soldier
in a white uniform.
The Soldier stood
taller than the Empire State Building
and the first thing He crushed
was the Statue of Liberty.

Albert M. Jabara
Thoughts Fall Like Rain
Wisdom House, 1984

STAGES IN THE NATIONAL LIBERATION STRUGGLE

PROBLEM: Are there various stages in a national liberation struggle or revolution?

RESPONSE: In-depth analysis of Malcolm's responses to our questions and his instructions to the O.A.A.U. as well as historical studies of successful struggles for national liberation or revolution reveal that, for instructional purposes, national liberation or revolution can be divided into the following theoretical stages:

Stage One
The people begin to doubt if the government policies, institutions and laws are able to achieve their beliefs, ideals and material needs. Economic difficulties expressed in terms of the system being overloaded with demand. Popular challenges to governmental decisions or the decisions of the traditional leadership. *The existence of revolutionary individuals and revolutionary individuals organized into an alliance of revolutionary groups (CRO).* The existence of popular challenges to certain existing institutions and to the moral authority of the ruling elites or classes. The lack of popular conviction that the perceived important problems can be solved within the framework of traditional politics. The ineffectiveness of the ruling elites of the oppressed masses in winning popular support for governmental problems. Indifference to voting for government officials. *It is at this stage that the revolutionary thinkers appear and begin the process of internationalization of the problem. That is, they begin to bring the question of Afro-American oppression to the attention of the world. This usually is done simply by domestic organizations of revolutionary thinkers extending branches outside of the country concerned for the purpose of acting in such a manner as to inform world opinion of the existing condition of oppression.* Such acts alone (given there is a significant condition of oppression) stimulate both moral and material support. The natural degree of this support will be determined by the degree and nature of the oppression as well as the degree and nature of popular resistance to the oppressor.

Stage Two

An acceleration of the processes mentioned above. The appearance of a central revolutionary diplomatic organization (CRO) usually both inside and outside of the country concerned which identifies with the popular masses' ideologies and attitudes. The CRO explains, rationalizes, encourages, defends and takes credit for revolutionary or popular acts of revolutionary individuals and groups. Such acts are rationalized in terms of initiating the revolutionary process. An increase in the popular tendency to discredit governmental and associated actions, institutions and programs.

Stage Three

The persistent and effective moral defence of popular and revolutionary acts by the CRO leads to its increased popularization and an increase in the popular tendency to discredit governmental traditional leadership and governmentally sponsored and associated institutions. Salient features of stages one and two are accelerated.

Stage Four

The popularization of the CRO provides the CRO with greater moral influence, and it becomes a key factor in shaping the opinions and attitudes of the masses, particularly in relation to the government, and in the case of Afro-Americans, the irresponsible traditional negro leadership. At this stage, the salient features mentioned in stages one, two and three are identified and explained.

Stage Five

The CRO, by its moral influence and popularity, begins to guide and influence the actions and determine the attitudes of the masses in relation to the government and irresponsible traditional negro leadership. *A decentralization of authority begins to appear as the government or irresponsible traditional negro leadership is increasingly forced to compete with the CRO for the allegiance of the masses.* This stage resembles anarchism where authority, particularly moral and effective authority, is divided among numerous smaller societal entities and communities. This is the beginning of the transition stage. The salient features of stages one through four continue to expand and intensify.

Stage Six

At this stage, if the government or its sponsored negro leadership fails to win the real allegiance of the Afro-American masses for its decisions and program, a contradiction of power exists. Two major contradicting centers of power will develop. The government and its sponsored leadership, which still holds the monopoly of military and economic coercion, will no longer hold a complementary and appropriate degree of popular influence. It will be in the process of becoming the de jure center of coercive power while the CRO will be in the process of becoming the de facto center of socio-political power. Thus, the salient factors already mentioned become the dominant popular tendencies. The power transition has begun. Thus, the maintenance of the revolutionary process is almost assured.

Stage Seven

At this stage, if the government or its sponsored negro leadership does not resign, collapse or permit the demands of the CRO (some form of political autonomy to the oppressed minority, in this case, the Afro-Americans), *it is left with no alternative other than the use of physical force without popular sanction and against popular actions.* Such popular actions at this stage usually take the form of general strikes or mass demonstrations, etc.. The goal of all popular actions becomes the replacement of the government or its sponsored leadership through the new popular leaders of the CRO or some degree of socio-political independence from the political control and socio-economic institutions of the governing body. Salient features mentioned in stages one through six have become all-pervasive and are consciously encouraged as tactics by the masses to make it impossible for the government to effectively govern the oppressed or to function normally. The masses automatically become politicized around the CRO. *Anarchy, decentralization of authority or anarchism ˚becomes the order of the day as failure of governmental institutions and organizations create the need for Afro-American centralized authority or leave political vacuums, some that can be filled by the CRO and some that cannot be so filled by an as yet unestablished or officially recognized new de facto power center.* The South African situation is in this shape at the time of this writing. Note the report of the actions of the ANC (CRO) in the newspaper article on the following page. The circumstances at this

point bring the government to use abusively its only remaining symbol of power: its control over the military and police. At first this is done sparingly in hope that the threat of force can re-establish order. But if it does not, the recourse to force is employed in earnest.

Stage Eight

At this stage, if the revolutionary acts continue despite the use of force in earnest, large clashes by the popular masses seeking the overthrow of this or that government policy and/or its traditional negro leaders, as would be the case of the Afro-Americans, and large scale military violence by the government must now occur. The unpopular use of force leads to many injustices inflicted against the popular masses. This acts to mobilize and politicize other large segments of the oppressed community. This is largely true because the oppressed community no longer will have the choice of indifference. Each individual will find himself pushed by environmental circumstances towards one side or the other. The government and its sponsored leadership is now caught in a vicious cycle whereby it must use force to survive or maintain its authority over the oppressed, yet the very force it uses serves the purpose of completely discrediting the authority of the government in the eyes of the masses, both foreign and domestic. This stage continues until the government is effectively discredited and its use of morally unsanctioned violence has served to legitimize the use of organized defensive force against the government and its institutions. At this point the revolutionary individuals and groups begin to engage in violent vendetta with the police, government and its sponsored leadership, and act against economic as well as political targets. This stage must lead to the government outlawing the CRO, imprisoning some of it leaders, etc.... if this has not already occurred.

Stage Nine

At this stage, if the popular will to struggle continues, despite the price the masses are forced to pay, and the government is still unable to meet the popular demands, a military civil conflict occurs. The revolution enters the armed struggle stage. The CRO assists the revolutionary individuals in securing arms, diplomatic and logistic support. Soon there appear self-organized armed groups of

Pretoria reels as blacks taking over in townships

June 8/86

By Peter Goodspeed Toronto Star

JOHANNESBURG - In the teeming black slum of Alexandra, black radicals have dug anti-tank trenches in the dirt streets to stop soldiers from patrolling the township in armored personnel carriers.

In Soweto, a civic action committee is distributing leaflets ordering all black policemen and town councillors to resign by June 16, the 10th anniversary of the 1976 Soweto riots.

In Atteridgeville, a black township outside Pretoria, government officials have been forced to close six schools because of the "uncontrollable behavior" of students.

And in the Cape Town squatters' camp of Crossroads, South African police and soldiers were incapable of stopping four days of rioting that left more than 40 people dead and almost 30,000 others homeless late last month.

Across the land, there is growing evidence that the country's white-led minority government may be losing control of the black townships.

Government officials vehemently deny the suggestion and, taking their cue from President Pieter Botha, warn that South Africa has not yet exercised even a fraction of its military might in dealing with political unrest.

35,000 soldiers

Still, doubts linger despite the presence of 35,000 heavily-armed soldiers who have been called in to assist police in the townships.

Behind the ugly face of daily violence in the black communities looms the threat of violent repression or total chaos. In the last year, more than 35 black community and town councils have collapsed as black politicians, fearing for their lives, have resigned en masse.

In some townships, like Alexandra, entire town councils have quit and white administrators have been appointed to try and maintain such basic tasks as rent collection and garbage removal.

Chaos in the townships is so complete that South Africa's department of internal revenue

has stopped sending tax inspectors into black communities to check on the collection of sales taxes. And rent boycotts staged all across the country by angry blacks are estimated to have cost the government more than $42 million.

The government has also been forced to float an emergency $65.8 million loan to the white-led administration boards to make up for lost rents in the black townships.

The breakdown of local government in some black townships is so complete that protesting radicals — the "Comrades" — have successfully set up alternative governments of their own, based on a plan proposed by jailed black activist Nelson Mandela in 1953.

'People's courts'

Known as "the M plan," the scheme relies on a system of street committees, block leaders and neighborhood councils that operate what amounts to an underground government in opposition to town councils sanctioned by South Africa's white minority government.

In Eastern Cape Province use of the M-plan is so widespread, the Comrades have even begun collecting their own taxes. They operate "people's courts," organize township cleanup projects, build miniature parks and erect monuments to black political heroes.

They also co-ordinate black protest meetings, organize political funerals and enforce consumer boycotts. They have launched major campaigns to isolate, threaten, injure and sometimes even kill other blacks who have been condemned as collaborators with the apartheid system.

"The control the government has in the black townships hardly extends further than the short shooting range of a patrolling Casspir (an armored personnel carrier)," says MP Roger Hulley, of the opposition Progressive Federal party.

Government officials deny the charge, but Minister of Constitutional Development Chris Heunis declared the other day in Parliament that the outlawed African National Congress had chosen black local government as the battlefield on which it will try to bring about a "Moscow-controlled dictatorship."

Unless something is done "to restore the balance," he said, the ANC could succeed in making parts of the country ungovernable.

Heunis has a lot at stake in existing black local councils. As the chief architect of the government's apartheid reforms, he has relied heavily on local government to make his plans work.

Last month, when South Africa repealed its hated pass laws and unveiled a master plan for the "orderly urbanization" of black communities, Heunis placed responsibility for regulat

67

revolutionary individuals acting in common cause around the banner of the CRO. Such groups soon become, with the logistic and diplomatic assistance of the CRO, its resistance armies or urban guerrilla squads or armed forces of "one". Their aim now is to completely topple the irresponsible traditional negro leadership at all costs and to cause so much social, economic and political damage that the government will be willing to give in to the popular demands of the oppressed (minority, viz-a-viz. Afro-Americans) for an appropriate degree of national liberation and self-determination.

The armed conflict between the traditional leadership, government and armed revolutionary groups increases until it becomes a conflict between the CRO and government for the political authority over the state, group or national minority concerned. Each side attempts to prevent the other side from functioning effectively among the population concerned. If the conflict concerns solely a domestic uprising among members of the same nation or ethny, the resolution is likely to come only through armed conflict, military victory and military defeat. However, if the conflict involves the question of self-determination or greater political autonomy for a nation or ethnic group, and pits the rulers of the oppressor ruling group, *not its people*, against the popular masses of the oppressed ethny, the solution may be found in cost-benefit analysis. That is, if the fighting is *raised to a level where the ruling ethny sees it has more to lose in continuing the armed struggle than it has in providing the ethny or nation in revolt with an appropriate degree of self-determination, military victory becomes irrelevant, provided the oppressed nation is willing and able to continue fighting, at all costs and by any means necessary.* If the conflict involves both members of the majority ethny and an oppressed ethny's search for self-determination, resolution of the conflict will necessarily involve a higher degree of military defeat for the government. Still, national liberation for the ethny need not mean collapse of the system of the ruling ethny (depending on the degree the masses of that majority ethny have joined in the revolutionary cause), *but it does always mean that the government must be convinced that no matter how much force it uses, short of genocide or civil war it cannot stop the acts and nationally-destructive disintegrating effects of the oppressed ethnic group searching for national liberation.* Genocide is set as a limit because no ruling group in today's world could carry out genocide without

destroying itself as well, particularly if it has powerful international enemies and the internal CRO is able and willing to use weapons made legally available to it to knock out key economic, socio-political, industrial and communications institutions. In such a case, to contemplate genocide would be to contemplate suicide.

However, nothing is automatic. To start a revolution is easier than to maintain it, and to win a revolution depends on which side is in closest touch with reality (a complex matrix of circumstances and factors), and to a limited degree, on chance (an act of God). In the final analysis we may conclude that success depends on encouraging the masses to devise strategies for themselves that are keenly in touch with their situation, needs, capabilities and wishes. *Only God decides if a revolution begins, is maintained, and is victorious.* Men under the sway of natural laws act out their part and succumb or ride with the tides of historical circumstances. Victory is a process of being in tune with the age, and defeat results from being in disharmony with the times, the people and their circumstances.

THE BLACK BOOK:

The People's Heroes

*Somewhere in the wastelands of a swamp, two of
the people's heroes lie in a wet, cold hole
covered with cardboard and grass that makes them
invisible to their fellow human elements that
search them out for destruction.
But unlike the earthworms, they dream, dream
of the reality of their tomorrow. Like air,
they have moved among the enemy seeking to touch
-- and many have been crushed instead.
Expecting anything and the worst --
And their promise for tomorrow lies only in God --
Due to the situation, this is the only way they
can know human dignity and equality and
happiness and above all, peace of mind --
The inevitable revolution
is both the penalty and grace of Allah, of God.*

THE BIGGER PICTURE

PROBLEM: What is the goal of countries like the U.S. and its allies in the world?

RESPONSE: The major opposing ideologies dividing the international system are usually described by most political scientists in terms of capitalism versus communism. However, while this view was no doubt fundamentally accurate in 1945-1960, at some point during the 1960's after the collapse of the Bretton Wood monetary policies, the Alliance For Progress program in Latin America, the peace efforts in Vietnam, etc. and the establishment of the Trilateral Commission, this conceptualization became non-functional and increasingly useless in explaining international events and the politics of states. However, Malcolm's statements concerning the international system suggest that when we review the actual trade, monetary and political decisions advocated by statesmen and politicians from the capitalist or liberal democratic countries over the past few years, we find a consistent tendency of their politico-economic acts and policies to be in contradiction to the bare minimum requirements of the ideology of free trade, supply-demand, capitalism. At the same time, we find numerous policies which are in keeping with the principles of capitalism. Extreme examples can be seen in NATO-allied countries which are considered and accepted as part of the western liberal democratic capitalist economy, such as Sweden, Greece, Spain and France, which have recently elected so-called socialist governments. Malcolm concluded that if the ideological forces of capitalism are confronted with the ideological forces of communism, and their philosophies are the salient factors in the present international struggle, then the countries expounding such ideologies should actually be attempting to apply tenets of such ideologies in the processes of their development and global inter- and intra-state relations -- which is not what's happening.

A projection of Malcolm's reasoning would lead to the conclusion that at some point, the leaders of capitalist countries stopped believing in the automatic and universal benefits of the economic and political theories of capitalism. They no longer believe that they are scientific and if applied to themselves and other countries evenly, would lead to continuous development. At the same time, they were

71

awed by the advantages that colonialism and imperialist conquest had brought to them in relation to the colonialized and communist worlds. They also realized that the adoption of socialist ideology would mean the loss of many economic advantages and privileges accumulated through colonialism and imperialism. They realized that their advantages and privileges were not the just result of their labor in the superior operation of capitalism as a system in which all players start even, but rather came from the exploitation of the now completely discredited aspects of capitalism, the slave and colonial systems. Due to their political and economic advantages, they are generally unable to muster the will to change, and adopt less profitable, more universal, scientific and humane ideologies for mutual international development, be it social democracy or socialism, etc.. After the dilemma and conflict that ensued from this widespread realization among leaders in capitalist countries, they have adopted American pragmatism or *Americanism -- the maintenance of the status quo or their present economic and military superiority at all costs, through the fostering of neocolonialism and the ideology of white racism or European ethno-centralism* . Their failures are due largely to the fact that the U.S.S.R, the largest European state, and its allies have refused to go along with either of these ideologies for the maintenance of the status quo. Thus, for them, the U.S.S.R. is their number one enemy.

Such an ideology as *Americanism*, a complicated and often contradictory array of pragmatic socio-economic and political reactionary policies and instrumentality designed essentially to maintain the status quo, concealed behind the classic ideals of capitalism and liberalism, however, gave a decided advantage among the developed countries to the U.S. and England. As the American, British and capitalist world economy faltered, the population in certain developed countries such as France found that they were losing certain advantages anyway, and could do just as well or better by forcing their ruling elites to partially adopt certain tenets from the more rational and universal ideology of socialism. Other developed countries in a similar situation also began to adopt (so-called) socialist governments, while the U.S. and England moved, through the election of President Ronald Reagan and Prime Minister Margaret Thatcher, to hold the alliance within the framework of *Americanism* by pushing international development (in the Third World

particularly) back to the premises of the capitalist free market which had served so well the politico-economic interest of the ruling classes in the developed western countries and their class allies in the Third World.

This effort, however, was aimed not at holding the western alliance together by a return to true capitalist ideology, but at a return to neocolonialism. In essence it was the adoption of *Americanism*, the chief difference between the two being that while capitalism (in theory) believed in the universal benefit and application of the capitalist theory, *Americanism* believes that the continued promotion of liberalism and capitalism as a cover for neocolonialism, best serves the interest of maintaining the NATO Alliance by maintaining the accumulated advantages gained through colonial and imperialist exploitation. It realizes that the western capitalist nations are in control of the capitalist and liberal institutions and can use these institutions for the ideology of *Americanism*. At best *Americanism* sees the western states as agents of world development, and assumes that Third World development or modernization and industrialization is either unimportant, or will result from the trickle-down effects of increased advanced development in the U.S. and, to some degree, in Europe.

Since *Americanism* is western/European-centered (that is, it sees the U.S., England and the other developed states as the urban, intellectual, cultural and industrial centers of the future world), the gap between the Third World peoples and those of Europe is seen as a natural process in world development, the same as the gap between Mississippi and New York State is a natural product of U.S. development. In this view, the Third World areas are seen as the mining, agricultural, vacation and affordable labor reserves of the world (or the international American capitalist economic system). In short, *Americanism* is nothing more than the effort at actual political implementation, institutionalization and maintenance of Samir Amin's economic model (which analyzes the actual reality of what is called world capitalism) and the military and diplomatic support for its eventual acceptance.

Due to its Eurocentric orientation (even within the territorial entity of the U.S. itself wherein the institutions of Americans of European, particularly English, origin dominate those of non-European or non-English origin), its overt embracing of Zionism, its covert assistance to South African apartheid, its encouragement or promotion of Third

THE BLACK BOOK:

World Eurocentric elites, particularly those of European origin or orientation, its Anglo-Americanization under duress of all internal minorities, its romance with the elitist philosophy of Plato and Aristotle, its misuse and unquestioning acceptance of Darwin's survival of the fittest thesis misapplied to human politico-economic and social development, etc., *Americanism*, like Zionism, promotes international racism or ethnocentrism only slightly disguised behind a philosophy of 19th century liberalism and capitalism. *Americanism* is a natural synthesis of the American historical experience with domestic colonialism, capitalism, and slavery. In this context, neither revolution nor significant institutional reform has occurred; the Anglo-Saxon history of the American provides elites with no precedents for national collapse and restructuring. Under most conditions of their historical heritage, the evolutionism of Darwin has held sway over rapid institutional change. It is only today that the burden of these ancient institutions and conceptualizations threatens to collide with international developments and social and politico-economic circumstances so as to impose the necessity for rapid change. If this is the case, it would be their first really significant such experience, and an extremely difficult one for the American elites. Because of their tendency to see correct world development exclusively in mirror-image fashion, they have not evolved the conceptualizations required to see and understand the major problems of the oppressed masses in today's world or in their own country.

The opposite pole to *Americanism* is usually referred to as *Communism*. However, there is some doubt as to whether the leaders of this ideology are in fact in the process of establishing the communist stateless society. If not abandoned completely, the international communist stateless society ideology has been placed on the back burner for propagation at a later date. Thus, it is the revolutionary force of the ideology of socialism and the new arrival to the international stage of reawakened Islam that actually confront the reactionary force of *Americanism* in the present day international arenas.

International socialism as developed by Marx and Lenin has its success rooted in the increased technological and scientific development of the past decades in the U.S.S.R. and China. The reawakened Islamic challenge has its destiny rooted in the success or failure of the Iranian revolution. The recent awakening of peoples in all

states to the inhuman significance of the world's immense productive capacity in relation to the existence of the bleak poverty and misery burdening 3/4 of mankind highlights a contradiction that results in shocking individuals into restructuring their thoughts concerning the cultural, economic, religious and political institutions and conceptualizations produced before and during the capitalist period. The success of the U.S.S.R.'s development and its ability to achieve modernization and military parity with the U.S. destroyed forever the intellectual and scientific sanctity of the thesis of the necessity of development through the economic encouragement and support of a small privileged class deemed alone capable of producing it. It also removed or eliminated the Anglo-American pseudo-scientific notion that progress could not be obtained through social and political revolution. The possible success of the Iranian revolution also threatens to expose the corrupt and socially disarticulated nature of the U.S. and western civilization that too often desires to feel that it is the sole bearer of civilization.

Like the geophysical developmental philosophies of Velikofsky in relation to those of Darwin, the U.S.S.R.'s progress and development over a relatively short span of years, as the direct result of socio-economic and political revolution, represented a significant break with the preceding Russian institutions and conceptualization of society and the world. The Russian revolution provided the world with an example of an international ideology favoring the masses being adopted and implemented by the people of a country through revolution. This revolution and the numerous others that followed, created examples of progress and development through rapid socio-political change, and have today produced an international situation and environment wherein the masses are no longer effectively exposed to only one concept of development (to achieve life's necessities) of support for and obedience to capitalist elitist ruling classes. The international environment today is tense with the demands of the masses for an equal share in the wealth of their countries and the world, for the establishment of more equalized distribution systems and equal status relations, for the provision of jobs, public services and opportunities for the majority, etc.. *These demands plus the reawakening of the Islamic civilization and its more recent emergence on the international stage as a third universal theory for harmonized human material and spiritual development, all*

imply a short time period for the implementation of change in the U.S. policies if it is to remain a major power. The people of the U.S., like those everywhere, would profit; only the privileged few of the U.S., the ruling elites, would lose, and their loss would be only the loss of their unearned privileges.

Thus it is obvious that such demands, in the time period implied, suggest a future of revolutions -- social, economic, cultural and political upheavals on both the micro and macro levels of the international system. *Americanism,*[1] unwilling or unable to assimilate or truly understand these demands and thus to formulate alternative solutions, retrenches itself by a military buildup that serves to wave the spectacle of nuclear war in the hope of slowing the revolutionary process to one of maintenance of the status quo or at least evolutionary change. However, its recent loss of dominant influence in the U.N. and on the international stage in general to the forces of international socialism and reawakened Islam suggest that even the threat of nuclear war, which no one wants and no one dares unleash, is not enough to stem the tides of history. Hajji Malik El Shabazz believed that Afro-American liberation (given the objective conditions of the Afro-American, Native American, Chicanos and poor in the U.S.) would awaken the American people to the plight of the oppressed and poor, and to the socio-economic and political crimes resulting from the international systemic need for a new world order and the avoidance of catastrophe.[2]

[1]Note that anti-Americanism is not directed against the peoples of the U.S.. It refers to the international ideology of reaction and status-quo maintenance formulated by the U.S. ruling elites and government.

[2]See *Rio: Reshaping the International Order*, A Report to the Club of Rome, New York: New American Library, 1977.

The True Political Philosophy of Malcolm X

IN CONCLUDING, we hope that a clearer and more integrated picture of the political philosophy of El Hajj Malik El Shabazz has emerged from our presentation. The question of whether or not Malcolm's philosophy is correct or incorrect, radical or conservative, was not the concern of this research. However, we feel that the analysis in itself of a man so sincere and well remembered, has been well worth our effort. Where projections of his ideas from the principles he taught occur, we feel that these projections are absolutely valid, although they may include events and data that occured after his death.

Through the Eyes of the Poor

We immigrated with eyes and hearts wide open
-- We could not find you until we realized that
You were what we saw --
The Sahara is an oasis compared to *Boston*
a human desert covered by the hot parched sands
of exploitation. *New York* -- The center of the world
that turns on human vice and obtains its power
from the disintegration of human souls. For many,
it is the here and the hereafter.
Washington -- a monument that comes from elsewhere,
stands for nothing, yet towers above all.
Detroit, Los Angeles, Mobile, Atlanta, Chicago ...
Now that I have seen you all, I know
You are not cities but the legacy of buccaneers
-- Institutionalized hustles
 -- yet our only hope.

EPILOGUE

by Clarence Johnson

Although Hajji Malik El Shabazz is dead, like all martyrs, his ideas will probably be resuscitated by the people and in time, the images of the ironies of the injustice faced by Afro-Americans will drift into the consciousness of humanity like a heavy smog descending on a bright sunny day, and then the myth of America the free will explode, leaving in its wake the unspeakable sight, the refuse of an almost successful colonialism -- a domestic imperialism.

Yesterday, however, Malcolm X sought to tell a story explainable only by the effects of drums, screams, rotten eggs, beautiful art, bright sunshine through a rainy day, cries of passion, unlimited and undeserving love, ugly faces, monsters, frightened children, uncontrollable fire, rottenness, blackness, people dancing with head in hands and feet in mouths, warm summer nights, uncompromising understanding and care, parasites, insects, misplaced individuals attempting to survive, invisible being and normal everyday people, gnats, flies, hope beyond, unimaginable calmness, pressure, brains splattered on the sidewalks, perfume and daffodils, roses and azaleas, sand and sea, games, frustration, exploitation ... If such could have been presented, all at once, on the same stage while a huge capitalist beast stood guard, with his tongue licking a few with affection while his saliva drowned the masses, then the dimensions of Malcolm's presentation of the American tragedy would have been understood.

If the message of Hajji Malik El Shabazz is not absorbed by this oppressed portion of humanity, *black America will continue to become the minstrel dancers for a world in which they will have no part.* The U.S. imperialist system is projecting the internal conditions of black Americans onto the international stage where awaits the thongs of every and any capitalist elite. After more than three hundred years, the American negro is being moved from the position wherein he was only the freed slave of the Anglo-American, to a position wherein his services are being shared with all the U.S. capitalist allies. The perfectioners and sellers of the Afro-American musical heritage travel far and wide, stretch their hands and suffer their feet, take dope and allow themselves and the music of the people to be misused in any

and every manner, all in the service of a few U.S. dollars. And do they have a choice?

> *O mothers of faith and hope, it was you who wrote:*
> *My old grand parents and parents died*
> *under the heavy yoke. When we think of all*
> *the suffering our hearts fill up and choke.*
> *But we cannot fight like younger folks -- we*
> *are old,*
> *Brow-beaten and broke.*
> *But sons, don't be discouraged, whatever befall*
> *The dawn sometimes appears quite dark, after all.*

What happens when a nation or people are effectively suppressed, yet their objective existence is neither absorbed nor eliminated? When the oppressor's system is believed by him and by the world to be everlasting and, on the whole, successful, and given all (save the oppressed) favorable to human progress? When the oppressor is able to successfully prevent the oppressed from organizing a legitimate intellectual or armed resistance? When the God-given collective human right to exist of the oppressed cannot be expressed because of the overwhelming domestic and international character of the wealth, influence and power possessed by the oppressor, which allows him to orchestrate the orientation of minds in such a manner as to make a central mass leader such as Hajji Malik El Shabazz appear insignificant, to make the legitimate and human aspirations of the oppressed appear illogical or universally undesirable? When this has occurred, has the oppression achieved ultimate victory? The current norms of western world thought in relation to such areas as Palestine or South Africa leave us with the impression that a political "fait accompli" against the right of a people to exist means that the oppressor has won and that the people whose existence in oppression nevertheless remains an objective fact, must and will accept the imposed political "reality" in perpetuity.

To this vision, Malcolm, the son of the slave of Little, said "X" and became the great Muslim martyr, El Hajj Malik El Shabazz. So too, the coming of the Palestinian and South African resistance brings us to understand that ultimately the oppressor can never win. That through the operation of natural laws, the oppressed group will continue to

mount a counteraction or resistance, and that this resistance, although it may be outside of what we normally consider to be political or military spheres, will eventually bring about the end of the oppression. But we need not look to Palestine, South Africa, northern Ireland, colonial Algeria, south-west Africa, or the continual struggle of the Jewish people for justice after Germany's efforts to destroy them, to see this truth.

We may simply look at the U.S. today where, despite all its power and influence, fewer and fewer Anglo-Americans feel safe in the streets and institutions of their own cities, not to mention the cities outside of the U.S.. Why? Malcolm believed that when a politically successful oppression occurs, such as the U.S. (and South African) system of hidden domestic colonialism and imperialism, the oppressed do not surrender their ideal of justice and struggle, but instead are forced to internalize or reorganize the nature of their fight. The results are that the person of the oppressor and his institutions as well as the humanity of those accepting oppression for personal profit rightfully lose all moral legitimacy in the eyes of the oppressed. This occurs spontaneously (as in the riots) and often through planned individual and occasionally collective aggression against certain institutions, population and supporters of the oppressors (such as in South Africa or Israel.) Such acts only take on a political orientation when a revolutionary intelligentsia recognizes and defines them as such. *The oppressors' institutions and population with whom the oppressed has no social contact lose all moral legitimacy in the psychology of the successfully oppressed.* Certain oppressor governments are able to deal with this level of resistance by relegating it to the domain of criminality or terrorism and dealing with it through the daily operation of their police forces.

At first, such arrangements would appear ideal to the oppressor for the elimination of both the uncontrollable members of the oppressed and those expressing minority or cultural self-awareness, since in essence it would mean that any member of a minority deciding to resist the system or fight for the collective right to exist could be controlled by lumping both together and successfully relegating both to criminal status and imprisonment. Many oppressors attempt to handle resistance in this way, but only an accidentally powerful former colony like the U.S. or South Africa, with its largely mythological history of freedom, opportunity and democracy, can

seem to have succeeded. However as the awareness of the oppressed and colonialized peoples in the U.S. and South Africa increases, so too does the level of so-called criminal acts increase. Today crime in the U.S. has become an internationally condemned and serious domestic problem. It is doubtful that even the most successful modern state will be able to continue to defeat the just struggle of the oppressed on the international level, and at this most rooted psycho-social domestic level and continue to relegate the Afro-American liberation-orientated efforts for freedom to the level of criminal activity.

Malcolm asked, what does the U.S. capitalist elite dream of, when it remembers what has been and is being done to the sons and daughters of the poor and oppressed of the world? He suggested: Join hands, brothers and sisters, and construct the nightmare of mankind's enemy that will conquer him even in his dreams. Or charge, like gallant knights, into the bottomless pit of the official American dream.

For those who believe that victory is possible, Hajji Malik El Shabazz said that the word is **Afro-American Self-Determination and replacement of the irresponsible traditional negro leadership** by responsible leadership who publicly support some form and degree of political autonomy or political independence. Not because it is the ideal and alone will solve all problems, but because in the imperfect world in which we live, it is the most available and useful tool by which to move toward the ideal goals celebrated in the great books of all ages – the Bible, the Quran, the Red Book, the Green Book, (the American Declaration of Independence), etc.. The movement for the freedom of the black American from Anglo-American capitalist domination must be in accordance with the requirements and expectations of all world movements for liberation. Afro-Americans must define themselves and their objectives and move with all men toward a greater and more meaningful freedom and happiness for the planet earth.

Malcolm knew that this period is a truly difficult period for Afro-American liberation organizations. However, he believed that as the U.S. capitalist elite loses its military, social and political hold on the minds of the majority of Americans and the world, each day becomes better. Tomorrow, he told us, would see turbulent environmental changes in the international system, and it is there that

Afro-Americans, other oppressed minorities, and the Anglo-American working class must and can act to free themselves. Some fight their nightmares with dreams, others with varying degrees of reality. But as witnessed by Malcolm's life and death, unspoken or unrecognized reality leads to a certain degree of individual danger and isolation in the situation of the present but dying world order. Certain forms of Afro-American oppression and exploitation are presently considered quite normal most places in the world of today, particularly in African and black communities. So why do they continue to sing "we shall overcome" when they know the present world system established by the U.S. capitalist elite conspires against their dream and is intent on keeping them, the oppressed of the world, in place, in the guise of maintaining international peace and order. Today if Malcolm was alive, we feel he would say:

They sing because they also know that they are preparing to struggle. Afro-Americans today must accept the past, not ignore it, must struggle to solve the problems of the past today, to change tomorrow, and be up to date. And they must fight only in defense of the path they have collectively chosen for themselves towards the goals of the people and the world.

APPENDIX

Hajji Malik El Shabazz' view of Minority Revolution - American Structural Change (An Abstract)

Although Hajji Malik El Shabazz focused on the Afro-American minority because of his awareness of its historical oppression, by no means, however, did he intend to imply that the trigger to revolution could not come from Spanish-American or Puerto Rican oppression, or native peoples' oppression or even that of the Irish, Italians, Greeks, etc.. (Indeed, the ethnic awareness and self-identity plus profound social and political changes in the homelands of Irish, Italian and Greek minorities may indicate just the opposite.) However, apart from the native Americans whose population is extremely small, and the Spanish and Puerto-Rican Americans whose perceptions of U.S. life are conditioned by the comparatively desperate conditions of life in their homelands, most other American minorities do not perceive themselves as oppressed to any significant degree and are not popularly seen as being minorities. (This may be true due to the success of the U.S. in the promotion of "white nationalism or racism" to merge the various European ethnies into a new white Anglo-Saxonized nation or ethny.) Also the popularly perceived position of Afro-Americans as being at the bottom of the politico-socio-economic scale provides a measurement whereby all other minorities see themselves as relatively better positioned. This suggests that a change in this perception may result in a corresponding change in the perception of other minorities, and of the non-Afro-American poor, the workers, etc..

At the same time, a decision to focus on Afro-Americans as the candidates for first in-group revolution raises many problems such as the fact that due to the emotionalism created by the racial issue in U.S. history and the accompanying disinformation, Afro-American masses have never seen their problems in terms of first, an in-group conflict for responsible representation or leadership, and secondly a fight against the U.S. government to achieve goals democratically formulated by the Afro-American people. The policies of their

leadership have never correctly conceptualized the need for ethnic identity and some form of ethnic self-determination. Instead they have accepted the authoritarian black leadership promoted by the U.S. ruling classes ("qualified leadership"). Their organizations have never been run by popular democratic processes. The Afro-American masses (like the masses in many Third World countries) are seen by their leadership as not being able to make the "right kind of decisions" and thus needing to be told what is best for them. This is manifested in the fact that most organizations spend most of their efforts in attempting to obtain mass Afro-American cooperation and participation in the decisions and programs which they dictate. Thus, for these organizations, the problem of the Afro-American masses is that they do not support "their people." This racist concept assumes that if the masses do not support the decisions dictated by the elitist few (sponsored by the white nation) and the elitist few are the same color as the masses, then the masses do not support their people. It would be very difficult to find any "Afro-American organization" or "leader" who finds nothing particularly wrong with the Afro-American masses except their collective historical oppression. Again like most Americans, the Afro-American elites place emphasis on the responsibility of the individual to make a social structure work regardless, not on those responsible to restructure the institutions and organizations to work for the individuals in the masses, etc..

Given such above factors, the Afro-American struggle has revolved around the improbable search for absorption into the Anglo-American ethnic identity. Of course, there are individuals and groups of Afro-Americans who don't accept this goal as respectable, desirable or practical. *But no matter how fiery their protests or widespread their mass following, they were always content to allow the appointed black "leadership" to carry the direction of the people, while they spent their efforts and resources in attacking, not these "black leaders and organization", but the people, for following the only road actually opened from poverty, and the "white man" (U.S. ruling elites) for protecting their own class interests as well as the interest of their black allies.* The U.S. ruling elites, unable to operate effectively in the Afro-American community themselves, have appointed or promoted Afro-American "leaders" who are thus able to operate with impunity among the masses. Because they are black though not necessarily Afro-American, this segment of the U.S.

ruling classes appears to be in a position, with the government's support, to forever succeed in determining the direction and content of the struggle of the Afro-American masses for equality.

However, this system of control, along with that of the politic of the "good job"[1], is totally dependent on the lack of sophistication of the Afro-American revolutionary intelligentsia and on their predilection for continuously focusing each aspect of their struggle around the generalized, undefined and often irrelevant but highly emotional question of race and racism. In short, choosing this minority poses a problem because the efforts of its existing intelligentsia have been misdirected toward attempting to solve the political, economic and social problems of the Afro-American masses through a solution to the universal question of national and international racism. Race has been projected as the sole reason for their oppression in order to divert their attention from cultural and economic reasons that can be understood and politically resolved. *The Afro-American was not taken from Africa and transported to the U.S. because he was black. He, the Indians, the indentured white servants were not enslaved for the purpose of color. Neither does the exploitation and oppression of the Afro-American exist today because he is black.* Exploitation always results from the search for cultural domination, profit and privileges.

Hajji Malik El Shabazz contended that when the real reasons of Afro-American oppression are focused on, real solutions will be sought, and that such solutions may entail an Afro-American national liberation struggle and consequent rapid structural and institutional changes favoring the masses of all the oppressed people in the U.S., with the ultimate beneficial result of ensuring the emergence of a mature, less prejudiced, strong and sensitive U.S. society.

According to Hajji Malik El Shabazz' view, then, the historical oppression of the Afro-American and the general subjective recognition of this oppression on the part of the American and

[1]The politic of the "good job" is a control mechanism which suggests if one does not cooperate with the elites, one cannot secure suitable employment. This mechanism is particularly important in a country where the human right to work is completely ignored, where minority unemployment is kept high and where employment opportunities for minorities are severely limited.

International consciousness may provide the natural basis for a rapid structural change in the U.S.. Malcolm suggested that it is only the existence of real historical oppression that gives a group the cohesive anti-institutional base necessary to start, maintain and win a revolution or national liberation struggle in the 20th century. He emphasized that this anti-institutional basis need not, and indeed cannot, be artificially organized. It can only be allowed and encouraged to manifest itself, and in so doing, shape the nature of the revolution.

When the Afro-American revolutionary intelligentsia develops to a point wherein it accepts the people and their condition as is, when it realizes the political nature of revolutions and national liberation, when it acts not to direct or organize but simply to release the impetus toward progress of the anti-institutional forces in whatever and any direction they may choose to take, when it decides to act to prevent anyone other than itself to speak on behalf of the people, a catalytic intra-community conflict will occur that will act to destroy oppressive institutions by humanizing and politicizing the masses. The political vacuum created can only be filled by organizations of the people. Of course, the ruling American elites may rush to the aid of their cherished Afro-American allies whose persons and programs will be under attack. This action alone can provide the popular basis for counteraction against American institutions in general, consequently awakening the masses of all peoples in the U.S. to the tragic necessity for the national liberation of the Afro-American and/or for structural changes in American society.

Conclusion

Malcolm X concluded that the callous historical oppression of the minorities in the U.S. through a particularly American form of covert domestic colonialism and internal imperialism has created the conditions whereby a revolutionary situation can be objectively observed to exist. *He believed that the existence of this situation provides the oppressed and progressive peoples of the world with a unique opportunity to achieve international structural changes and greater world equalization through the initiation of rapid change in the political structure of the U.S.. Therefore it is not only the moral duty, but it is in the immediate material interest of the masses of the world to provide full information and assistance to all peoples of the U.S. in their*

THE BLACK BOOK:

difficult efforts to promote rapid structural changes in the political system and thus eliminate the strongest weight acting against the necessary changes in the international structure required to solve the awful problems of international poverty, oppression, illiteracy, etc.. Effective changes in the U.S. political structure would permit adequate changes in the international economic, political and social order. Appropriate changes in the international system (which are presently being demanded by most states) would mean the release of resources towards finding solutions to the problem of the grossly unequal distribution of the world's wealth and productive capacity caused by the relentless search for, and maximization of, profits in the interest of the super-rich few.[1] In summary, Hajji Malik El Shabazz attempted to deliver the message to the American people and to the world that, given the power of the U.S. and the existence of nuclear weapons, the international developmental crisis is unlikely to be solved until the masses of the American people are effectively informed, and are able to gain effective control of their institutions and government, both in their own interest and in that of a better world.

IN CONCLUDING, we feel that these projections of Malcolm's ideas from the basic principles of the philosophy he taught are valid representations of his ideas, although the analysis has been updated to include events occurring subsequent to his death.

[1]Francis Moore Lappe and Joseph Collins, *Food First*, Ballantine Books, 1979.

Materials Reviewed
for Analysis and Abstraction

Adoff, Arnold, *Malcolm X*, Crowell Jr. Books, 1970.

Baldwin, James, *The Fire Next Time*, Dell Books, 1985.

Barbour, Floyd. *The Black Power Revolt: A Collection of Essays*, Boston, MA.: Extending Horizons Books, 1968.

Blyden, Edward W., *Black Spokesmen*, Biblio Dist. 1971.

Breitman, George, *The Last Year of Malcolm X: The Evolution of a Revolutionary*, New York, Pathfinder Press, 1970.

Breitman, George et al, *The Assassination of Malcolm X*, New York, Pathfinder Press, 1977.

Charter of the O.A.A.U.

Clark, John Henrik, *Malcolm X: The Man and His Times*, New York, Macmillan, 1969.

Clark, Kenneth B., *King, Malcolm X, Baldwin: Three Interviews*, Wesleyan University Press, 1985.

Davis, Leonard G. & Moore, Marsha L., eds., *Malcolm X: A Selected Bibliography*, Greenwood Press, 1984.

Goldman, Peter L., *The Death and Life of Malcolm X*, University of Illinois Press, 1979.

Goodman, Benjamin, ed., *The End of White World Supremacy: Four Speeches of Malcolm X*, New York, Merlin House, Inc., 1971.

Frazier, E. Franklin, *The Black Bourgeoisie*, Free Press, 1965.

THE BLACK BOOK:

Hall, Raymond L., *Black Separatism and Social Reality*, Pergamon Press, 1977.

Holy Quran, Translation and Commentary by A. Yusif Ali, Amana Corp., 1983.

Interviews: Sister Ella Collins, Malcolm's sister
Mr. Mitchell of African Square Bookstore, Harlem
Mrs. Betty Shabazz, Malcolm's wife
Kenyatta 37X, Malcolm's assistant
Mohammed Ta'ha, Malcolm's assistant
Dr.Mahmoud Youssef Shawarbi,
Imam of New York Islamic Center

Jenkins, Betty L. & Phillis, Susan, eds., *The Black Separatism Controvery: An Annotated Bibliography*, Greenwood Press, 1976.

Johnson, ed., *Malcolm X: A Complete Annotated Bibliography*, Garland Publishing.

Karim, Imam B., Intro by, *The End of White World Supremacy: Four Speeches by Malcolm X*, Seaver Books, 1983.

Kly, Y.N., *International Law and the Black Minority in the U.S.*, Clarity Press, 1986.

Lincoln, Charles E., *The Black Muslims in America*, Greenwood, 1982.

Lomax, Louis E., *When the Word Is Given... A Report on Elijah Muhammad, Malcolm X and the Black Muslim World*, Greenwood, 1979.

Malcolm X, *Autobiography of Malcolm X*, Assisted by Alex Haley, New York, Grove Press, 1965.

_____, *Malcolm X Speaks: Selected Speeches and Statements*, Edited with Prefatory Notes by George Breitman, New York, Pathfinder Press, 1976.

_____, *Malcolm X Talks to Young People*, New York, The Young Socialist, 1965. (pamphlet)

_____, *Two Speeches by Malcolm X*, New York, Pioneer Publishers, 1965.

Marsh, Clifton E., *From Black Muslims to Muslims: The Transition from Separatism to Islam*, Scarecrow Books, 1984.

Matthews, Harry G., *Multinational Corporations and Black Power*, Schenkman Books Inc., 1976.

Moses, Wilson J., *Black Messiahs and Uncle Toms: Social and Literary Manipulations of a Religious Myth*, Pennsylvania State University Press, 1982.

Pinkney, A., *Red, Black and Green*, Cambridge University Press, 1976.

Randall, Dudley & Burroughs, Margaret G., eds., *For Malcolm: Poems on the Life & Death of Malcolm X*, Brownside, 1969.

Schwarzenberger, Georg, *The Inductive Approach to International Law*, Stevens and Sons, 1965.

Shalaby, Ibrahim, *Education of a Black Muslim*, Impresora Sahuaro, 1980.

Trostsky, Leon, *Leon Trotsky on Black Nationalism and Self-Determination*, Pathfinder Press, 1978.

Weisbord, Robert G., *Ebony Kinship: Africa, Africans and the Afro-American*, Greenwood, 1978.

White, Florence M., *Malcolm X: Black and Proud*, Garrard, 1975.

Wolfenstein, Eugene V., *The Victim of Democracy: Malcolm X and the Black Revolution*, University of California Press, 1981.